This Pictorial
*History of Menifee Valley,*
Is of the Menifee Valley and surrounding valleys and areas from 1880 to 1960 and dedicated to those individuals and families who lived that history as they worked the land or as they passed through our valleys.

The Menifee Valley Historical Association
menifeevalleyhistorical@earthlink.net
©August 2006

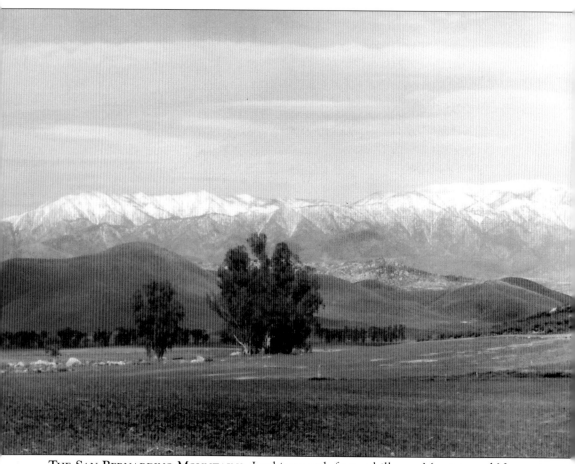

THE SAN BERNARDINO MOUNTAINS. Looking north from a hill near Murrieta and Newport Roads, one sees this scenic view of the San Bernardino Mountains. The hills in the foreground are south of present-day Sun City. The mountains that surround Menifee Valley provide a scene that changes according to the time of day and season and continues to be inspirational.

ON THE COVER: This photograph shows the William H. Brown family on Thanksgiving Day in 1913. Pictured, from left to right, are Rosamond, Walter, William, Margaret Brown, and Myra Kittilson.

# IMAGES of America
# MENIFEE VALLEY

Elinor Martin and Betty Bouris

ARCADIA PUBLISHING

Copyright © 2006 by Elinor Martin and Betty Bouris
ISBN 0-7385-3139-1

Published by Arcadia Publishing
Charleston SC, Chicago IL, Portsmouth NH, San Francisco CA

Printed in the United States of America

Library of Congress Catalog Card Number: 2006922514

For all general information contact Arcadia Publishing at:
Telephone 843-853-2070
Fax 843-853-0044
E-mail sales@arcadiapublishing.com
For customer service and orders:
Toll-Free 1-888-313-2665

Visit us on the Internet at www.arcadiapublishing.com

# CONTENTS

| | | |
|---|---|---|
| Acknowledgments | | 6 |
| Introduction | | 7 |
| 1. | Early Settlers | 9 |
| 2. | Farm Scenes | 21 |
| 3. | Homes | 37 |
| 4. | Farming and Commerce | 51 |
| 5. | Descendents and Other Residents | 73 |
| 6. | Clubs and Recreation | 99 |
| 7. | Schools | 111 |

# ACKNOWLEDGMENTS

The photographs and information in this book came from the private collections of Menifee Valley residents and other descendents of early settlers. Leta Evans asked residents in 1973 to write their memories of the valley in order to preserve its history. Many took the time to write, and this collection resides in the Menifee Valley Historical Association archives. Thank you for your foresight. The Menifee Valley Historical Association also has an impressive collection of photographs and newspaper clippings. We would like to thank the following persons who shared their collections and information: Lynn Arviso, Milton Beall, Betty Bouris, John Bouris, Peter Bouris, Linda Brown, Alice Burton, Tami Campbell, Herbert Christensen, Lyle Christensen, Julia Difani, Loretta Eckes, Mary Antha Harnish, Evelyn Hanks, John R. Harrison, Miami Hendry, Jean and Leonard Kirkpatrick Jr., Kathryn Krubsack, Sandra LaFon, Vince Magana, Elinor Martin, Nina McElwain, Ann McGrath, Andy McElhinney, Rosamond Morrison, Leon Motte, Louise Phillips, Texana Schaden, Alpha Schekel, Marcie Stimmel, Poula Terrick, Darleen Twyman, Rose Washburn, James Wickerd, Robert Wickerd, Paul Wright, Ina May Zeiders, Merle Zeiders, and William Zeiders. A special thanks to Sharon Zeiders Johnson and Rhoda Wright for their assistance.

# INTRODUCTION

Menifee Valley is located 80 miles north of San Diego and halfway between the cities of Perris and Temecula, just an hour each from coastal beaches and mountain resorts. Nestled between several mountain ranges, it was a peaceful setting for early explorers, miners, and those looking to homestead property. The Lueseno Indians were hunters and gatherers in the area before early settlers moved in, however, this pictorial history covers the period from 1880 to 1960 when Del Webb built Sun City.

The valley was named Menifee after Luther Menifee Wilson, an early miner. The area had another name, Paloma (the Spanish word for dove) Valley. Residents on the southeast side of the valley preferred the Spanish designation, while Menifee seemed to be the choice for the other parts of the area. Eventually Menifee became the official name. The valley was part of San Diego County until Riverside County formed in 1893.

People began to arrive and locate land they could homestead or purchase, and young families from the east were looking for new horizons. Most were farmers who discovered that wheat thrived in this dry climate. There was a mixture of different nationalities all living peacefully in the valley.

The one-room schools housed grades one through eight, with as many as 18 students and a minimum of six. Paloma School was on the northwest corner of Garbani and Leon Roads, while the first Menifee School was built in 1890 on the southwest corner of Bradley and Newport Roads. The Antelope School, located on the southeast corner of Scott and Antelope Roads, unified with the Menifee School in 1952, and a new building was erected at Garbani and Murrieta Roads on the old Henry Evans ranch.

Del Webb envisioned a vast senior development like the one in Arizona and began buying property in the valley. He purchased the large ranches for a total of 14,000 acres in 1960. His plans did not work out; instead, the town built on 1,200 acres is the Sun City core. The remaining property sold several times and eventually new family housing developments built around the senior area.

Today it is hard to imagine the serene valley early settlers saw upon their arrival. There is an influx of new residents today that live different lifestyles, and hopefully the photographs in this book will give them a glimpse of what life was like in those early years.

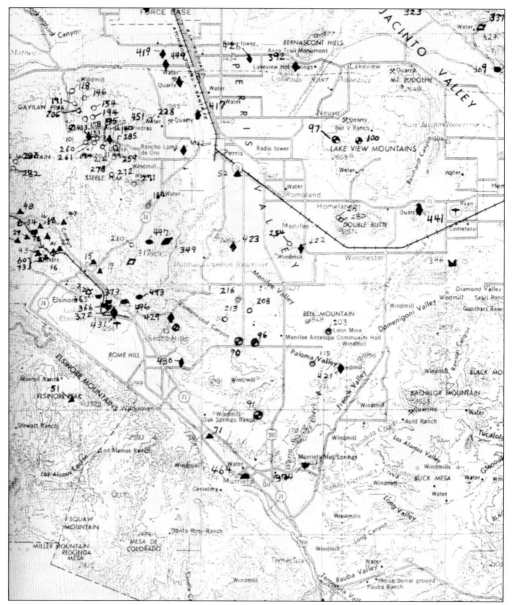

**MENIFEE MINING MAP.** Luther Menifee Wilson came from Kentucky to the northern part of San Diego County sometime around 1880 and began prospecting. He found gold quartz and quickly secured mining claims around what he called the Menifee Quartz Lode. The Menifee mine was near present-day Murrieta and Holland Roads. Gold fever led to the filing of hundreds of mining claims in the hills surrounding the area that was becoming known as the Menifee Valley. The dots on this map represent the many gold and silica mines. (Courtesy Menifee Valley Historical Society.)

# One

# EARLY SETTLERS

NORMA KITTILSON BROWN. Andrew Kittilson was born in Norway and migrated to the United States at age 16, where he met and married Myra Morrell. They came to Paloma Valley in November 1882, when daughter Norma was five years of age. Her father had arrived in the spring and built a house on his homestead property in Section 14. The house was of board-and-batten construction. It was a two-day trip from Los Angeles by wagon and two horses, and most of their household goods had been shipped to Colton to be picked up later. Andrew died in 1906 and Myra in 1931. (Courtesy Rosamond Morrison.)

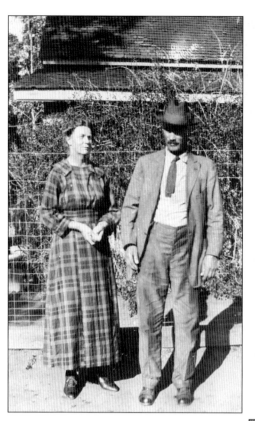

**WILLIAM H. AND NORMA BROWN.** William (1869–1946) was born in Illinois and came to Los Angeles around 1891 and worked various jobs. Mrs. Beall asked him if he wanted to go to the country and farm her ranch. It was there he met Norma Kittilson (1877–1963), and they were married in 1899. Their family included children Margaret, Walter, Hazel, and Rosamond. (Courtesy Rosamond Morrison.)

**WILLIAM T. AND CALLIE KIRKPATRICK.** Robert Kirkpatrick, a native of Tennessee, came west with his four sons after his wife died. He purchased land in Menifee and began farming. William (Robert's son) moved with his wife, Callie, to the ranch in 1882 and later built a large house and continued farming. She was a teacher and the Callie Kirkpatrick School is named for her. The ranch was located at the southeast corner of Newport and Antelope Roads. (Courtesy Julia Difani.)

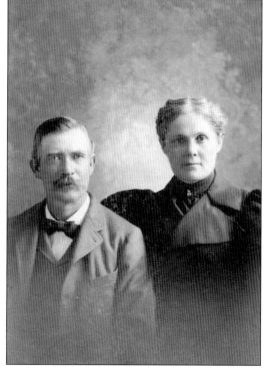

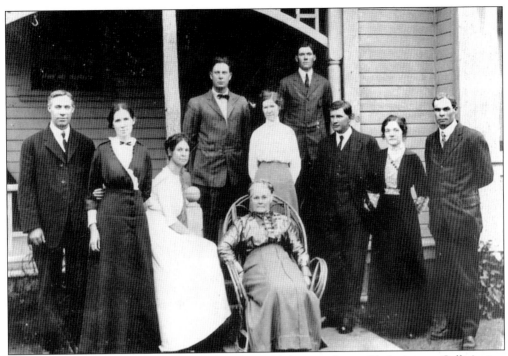

**CALLIE KIRKPATRICK'S CHILDREN.** Gathered around their mother at Christmas are Callie's nine children: Lula, Robert, Wert, Bettie, Mary, Jennie, Felix, Lloyd, and Leonard (standing in the back on the porch). Most of the children attended Menifee School. Some of the younger ones attended high school in Riverside. (Courtesy Julia Difani.)

**KIRKPATRICK GRANDCHILDREN, 1921.** Pictured, from left to right, are Dorothea O'Neil, Margaret Kirkpatrick, Glen Kirkpatrick, Dwight Velzy Jr., and Virginia Velzy. The photograph was taken at Christmas in 1921 at Grandma Callie Kirkpatrick's home in Menifee. Their fathers are in the background near the barn. (Courtesy Julia Difani.)

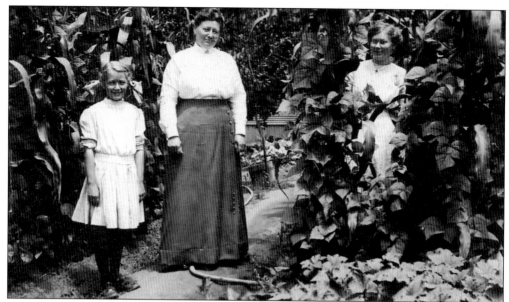

ROSETTA HOLLAND CHRISTENSEN. The William Frank Holland family owned large acreage that reached from Scott Road to Garbani Road. Holland Road is named for this family. A few eucalyptus trees on Scott Road are all that remain of the homestead. Rosetta (daughter of William F. Holland) married Hans Christensen Sr. in 1892 and moved to their home on Antelope and Garbani Roads. She is pictured here with daughters Aleen and Ellen. (Courtesy Herbert Christensen.)

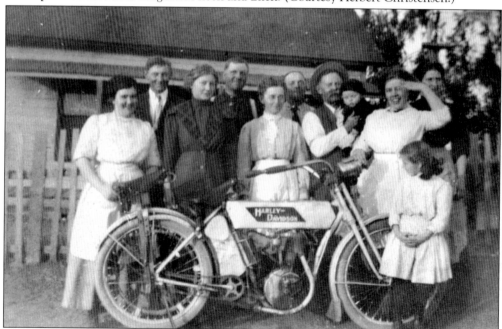

THREE GENERATIONS OF CHRISTENSEN FAMILY. Hans Christensen Jr. is standing second from the left in this photograph. Hans Sr. (fourth from right with grandson Clyde in arms) was born in Denmark, arrived in America in 1877, and spent 41 years in Riverside County. Three generations are in this image. The group is in Murrieta, but the occasion is unknown. The Harley Davidson motorcycle belongs to Hans Jr. (Courtesy Lyle Christensen.)

NEWPORT FAMILY, 1913. The Newport family is posing at their ranch, located on the north side of Newport Road between Murrieta and Bradley Roads. Pictured here are Mary Catherine (mother), Lloyd, Samuel, Frederick, Mary Kathryn (on horse), George, William (father), and two unidentified ladies. The parents had emigrated from Chester, England. The children born in Menifee attended local schools. (Courtesy Newport family album.)

NEWPORT FAMILY AND FRIENDS. Posing here is some of the Newport family with friends in 1913. Pictured in front of the ranch house, from left to right, are William Newport, Halabrid, Mary Kathryn, Lloyd, Dibble, Mary Catherine, and McClure. Friends would motor out to the ranch to show their new cars, as it was a scenic trip from neighboring towns. (Courtesy Newport family album.)

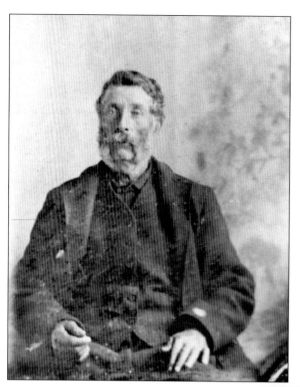

**JAMES B. FERRELL, C. 1887.** In 1887, James B. Ferrell came to Menifee Valley from San Bernardino and homesteaded on the area now known as the Audie Murphy ranch. He had built a six-room house and barn by 1889. His daughter Ella lived nearby with her husband, Henry Evans. James raised trotter horses among other occupations. Iowa records show him as a third-degree Mason in 1866. (Courtesy Elinor Martin.)

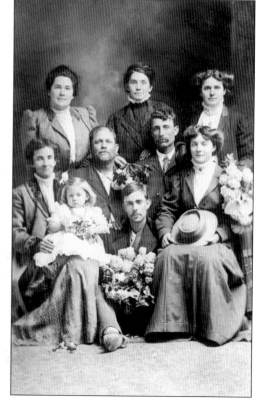

**EVANS AND FERRELL FAMILY.** Pictured here, from left to right, are (first row) Baby Violet Evans, James Ferrell, and Bonnie Whitten; (second row) Ella Evans, Henry Evans, and Roy Ferrell; and (third row) Edna Ferrell, Cousin Effie, and Minnie Ferrell. Two of Henry's sisters married two of his wife's brothers. This photograph was taken around 1909. (Courtesy Elinor Martin.)

**JOSEPH AND HARRIET DRAKE.** Joseph F. and Harriet P. Drake came to Menifee Valley from Lawrence County, Pennsylvania, in 1887 with their children Elluard H., Alden T., Freeman, and Lois Viola. They bought 80 acres near Zeiders and Keller Roads, and the family farmed wheat there. Joseph passed away in 1888, Freeman in 1887 shortly after their arrival, and Viola in 1905, leaving Harriet and her two sons to run the ranch. (Courtesy Betty Bouris.)

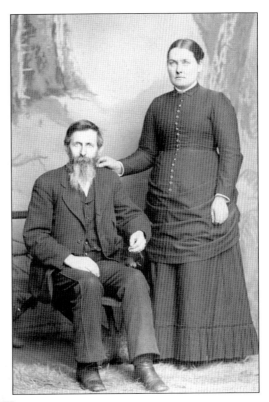

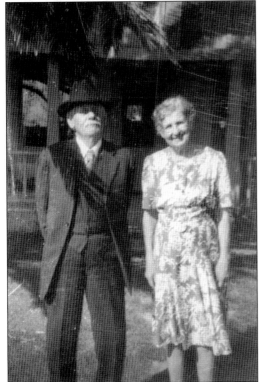

**ELLUARD AND ELIZABETH DRAKE.** Pictured here are Elluard H. and his wife, Elizabeth (Weldon) Drake, in 1944. They were natives of Pennsylvania and married in 1914. They had no children, but were aunt and uncle to several nieces and nephews in the valley. Known as "Aunt Lizzie," Elizabeth taught 4-H sewing in her home on Zeiders Road. She also taught Sunday school in the little one-room Antelope School house. (Courtesy Betty Bouris.)

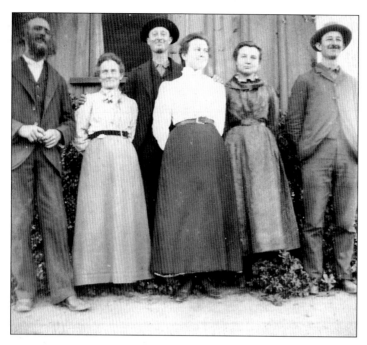

**Samuel Walker Family.** Samuel came from Illinois and his wife, Alice Wickerd, from Michigan. They married on New Years Eve 1875 and came to Menifee about 10 years later from Ventura, California. Pictured here, from left to right, are Samuel, Alice, John, Zona, Callie, and Claude Walker. Alice was the daughter of Isaiah and Affa Wickerd. The Walker ranch was located on Haun Road. The sons never married, but the girls united the Drake and Roberts family. (Courtesy Linda Brown.)

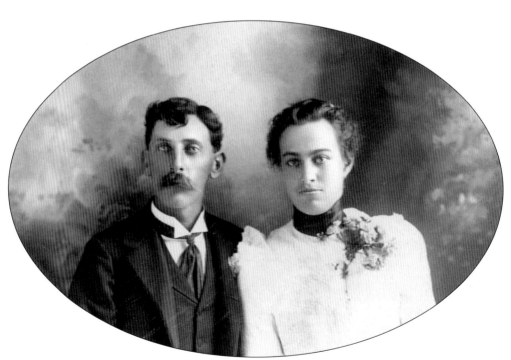

**Alden and Zona Drake.** Alden T. Drake came to Menifee Valley with his parents in 1887. He helped run the farm with his mother and brother after their father died. Zona Walker and Alden married in 1901 and raised children Nina, Daryl, Deone, Sarah, and Iva. They lived south of Scott Road and west of Briggs Road. The children married neighbors, and most of them resided in Menifee and raised their families. (Courtesy Betty Bouris.)

**HENRY H. EVANS (1863–1930).** Henry was born in Gilroy, California. He married Ella Ferrell in San Bernardino and moved to Menifee in January 1890. Their children were born in Menifee. He was appointed district road foreman in 1915 and moved to the southeast corner of Garbani and Murrieta Roads. Six generations of his descendents have lived in Menifee. Recently the Evans Ranch Elementary School was named for him. (Courtesy Elinor Martin.)

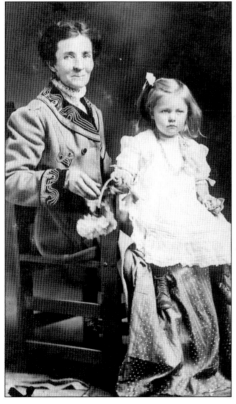

**ELLA FERRELL EVANS (1866–1949).** Ella Ferrell was born in Lewis, Iowa. She married Henry Evans in 1885 in San Bernardino and came to Menifee in 1890. She is pictured here with her daughter Violet around 1909, the youngest of her eight children. After her husband's death, she lived in Riverside for a few years and then returned to her daughter's home on Murrieta Road. (Courtesy Elinor Martin.)

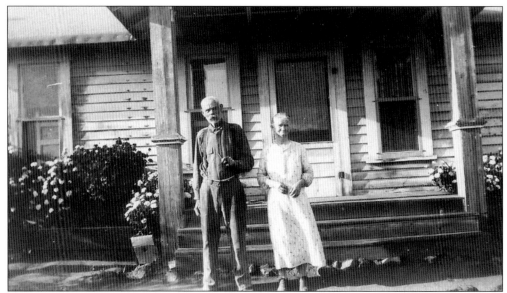

RICHARD AND DELIA HARRISON. Richard Harrison was born in England and his wife in Ireland. They met in Murrieta and were married there in February 1896. Their home was in the foothills at the south end of the valley that separated Menifee from Murrieta. Their children were John Henry, Sarah, and Mary. Descendents still live in Menifee and are the fifth generation of this couple. (Courtesy John R. Harrison.)

BENJAMIN KOHLMIER JR. AND PARENTS. Benjamin "Benny" Kohlmier Jr. (left) came to Menifee Valley around 1900. His parents bought 660 acres of land that included a ranch. Benny spent most of his life on that ranch and the children of Richard Harrison worked on it when they were young. Later the Kohlmiers deeded the ranch to John Harrison for taking care of it through the years. (Courtesy John R. Harrison.)

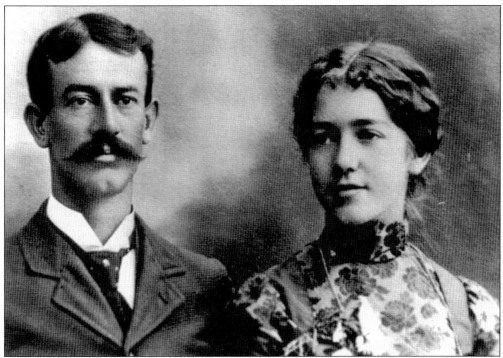

DAVID AND LEONA WICKERD. This couple was married in August 1900 and came to Menifee 10 years later. His brother John arrived in 1907 with his wife and eight children. The entire family had all lived previously in Eagle Rock, California. Their combined properties extended north from Scott Road to Wickerd Road and west of Bradley Road. (Courtesy Loretta Eckes.)

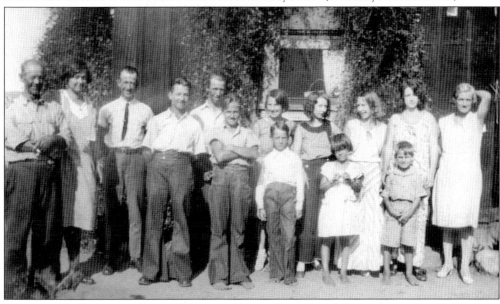

CHILDREN OF DAVID AND LEONA WICKERD. Pictured here, from left to right, are David, Margaret, Frank, Austin, George, Jack, Ina, Walter, Clara, Ruth, Winona, Erma, Karl, and Leona. Winona was their first child born in Menifee in 1910. The children married, built houses, and raised families on the same land. The area was nicknamed Wickerdville. (Courtesy Loretta Eckes.)

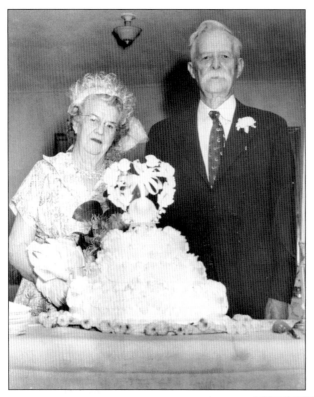

**JOHN AND MAUDE MCGRATH, 1955.** They were celebrating their 60th wedding anniversary when this photograph was taken. John (1870–1961) was born in Nevada, and Maude (1875–1967) was born in Massachusetts. They arrived in Menifee from Santa Barbara in 1912. He was a beekeeper and worked on the Liberty ranch. Descendents living here now are the fifth generation. (Courtesy Herbert Christensen.)

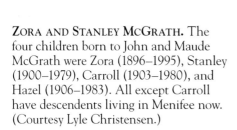

**ZORA AND STANLEY MCGRATH.** The four children born to John and Maude McGrath were Zora (1896–1995), Stanley (1900–1979), Carroll (1903–1980), and Hazel (1906–1983). All except Carroll have descendents living in Menifee now. (Courtesy Lyle Christensen.)

# Two

# FARM SCENES

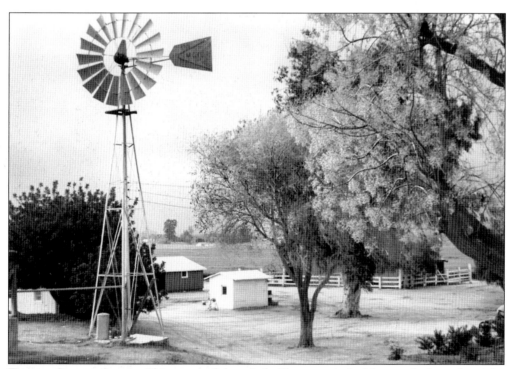

**TYPICAL RANCH SCENE.** This scene of the windmill was typical of farmyards throughout the Menifee Valley from the 1880s to 1970. Wells with windmills were the only water source until they were later replaced by gas engines that pumped water for households, orchards, fields, gardens, and livestock. Eastern Municipal Water District brought the first public water into service when 10,000 acres in the valley were annexed to it in 1963. (Courtesy EMWD.)

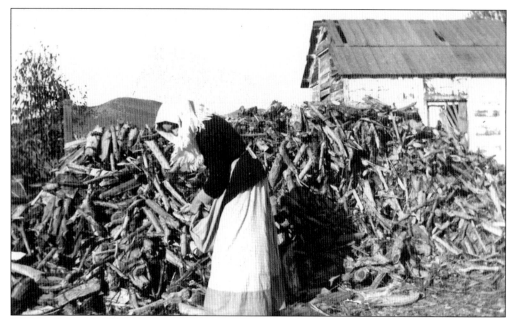

**BROWN FAMILY'S WOODPILE, 1912.** Myra Kittilson is picking up wood for the kitchen stove and room heater. She was the mother of Norma Brown and spent her later years with the family. A large woodpile was a necessity, since that was the only source of heat for cooking and heating the house. (Courtesy Rosamond Morrison.)

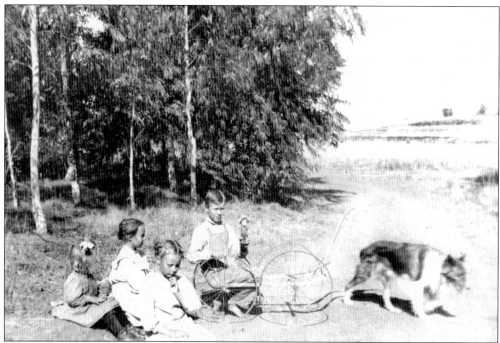

**CHILDREN AT PLAY, C. 1912.** Children amused themselves and did not need many toys, and Rosamond, Margaret, Hazel, and Walter Brown are pictured here playing with their collie around 1912 or 1913. The location was the cottonwood grove east of the homestead at Garbani and Antelope Roads. (Courtesy Rosamond Morrison.)

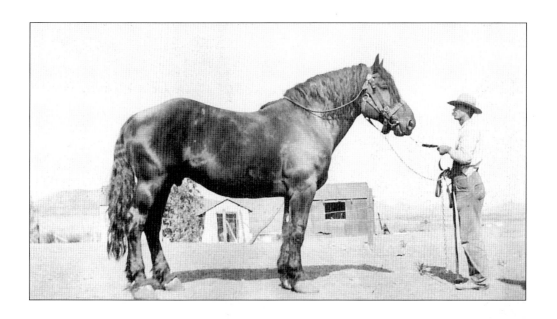

**WILLIAM H. BROWN AND D'ARTAGNAN.** D'Artagnan was a Percheron stallion purchased by the Leon Percheron Horse Company in 1906 for breeding workhorses. He came by ship from France at the age of three. He was taken off the ship and allowed to exercise at each port stop. The trip took between one and two weeks, and once he arrived, he was placed in a separate area at Brown's farm under the care of Riley Conley. The Leon Horse Company was composed of A. S. Baxter, J. A. Holland, W. H. Brown, John Rawson, E. H. Drake, and George M. Simmons. The bottom photograph, taken in August 1912, shows Norma Brown with Bess, the mare, and D'Artagnan's offspring. (Courtesy Rosamond Morrison.)

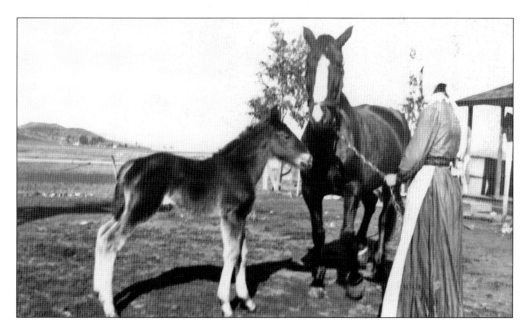

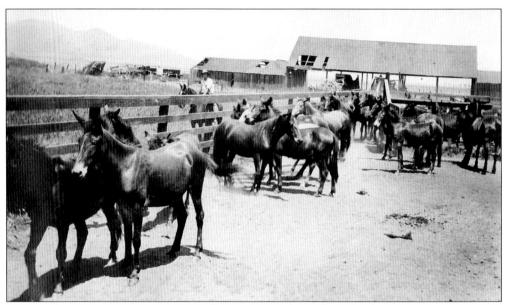

MULES ON THE NEWPORT RANCH. William Newport had a large herd of mules he used to pull the machinery in his farming. He also had another large herd of horses for pulling his harvesters. His farming was on a large scale and was an impressive operation. Many of the young men in the valley were on his payroll. (Newport family album.)

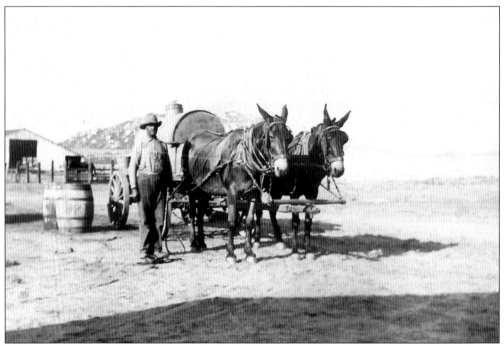

NEWPORT'S WATER WAGON. Pete is the hired hand pictured here getting ready to deliver water to livestock in the corrals. It was an endless job with so many animals to tend. The ranch had many wells, but hauling water was still a necessity. (Newport family album.)

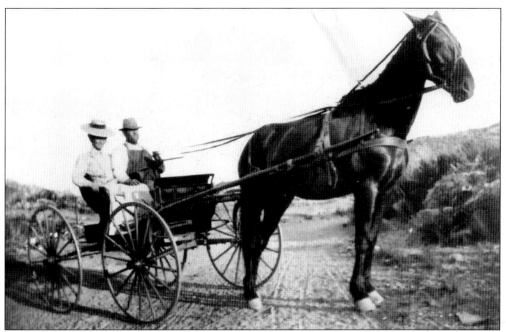

HENRY AND ELLA EVANS. Henry and Ella Evans are ready to go visiting in their buggy. Neighbors were far and few between, so this was the best transportation in those early days. Perris and Winchester were the closest places to get supplies. The newspaper reported that in November, Henry put in his order for a 1916 four-door Ford. Later he was seen driving around and showing it to his friends. (Courtesy Elinor Martin.)

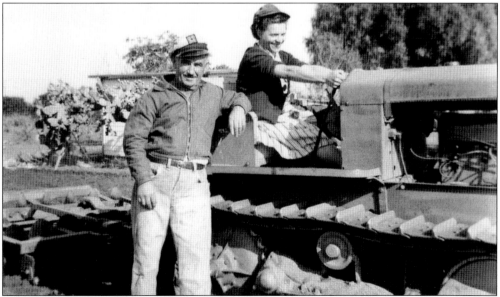

SAM AND MARIA BOURIS. Maria Bouris, pictured here playing on the Allis Chalmers "M" with her husband, Sam, was newly arrived at the Bouris Brothers ranch as a bride from Greece. The machinery fascinated her. It was uncommon for women to drive tractors in Menifee Valley. Instead they tended livestock and gardens, cooked for the planting and harvest crews, and preserved fruit and vegetables. (Courtesy Betty Bouris.)

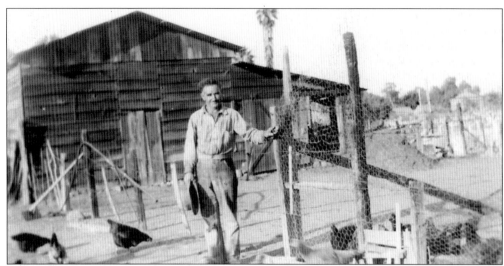

FREE-RANGE CHICKENS. Chickens raised on the farms provided food and eggs. They ran free during the day and spent the night in pens. Coyotes were a danger after dark and it was usually the children's duty to put them in the pen. Pictured here is Sam Bouris next to the barn and chicken pen. (Courtesy Peter Bouris.)

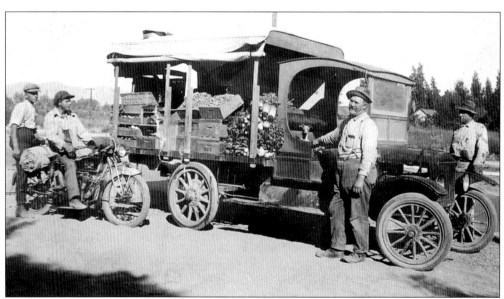

McGOON, THE PEDDLER. A peddler named McGoon delivered fruit and vegetables to homes in the area, for shopping meant a trip to Perris, Elsinore, or Winchester. The Helms Bakery arrived on the scene a little later. In addition, another peddler by the name of Frenchy sold candy and other sundries. He would stop if the schoolchildren waved at him and sell them sweets, but he would never give them a ride home. (Courtesy Darleen Twyman.)

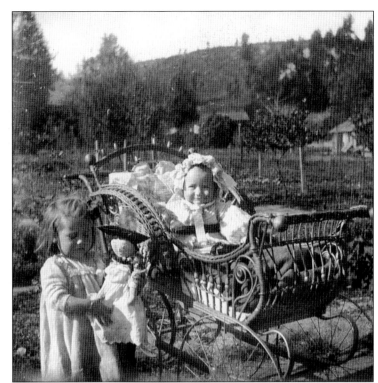

INA AND CLARA WICKERD. The baby in this Victorian buggy is Clara, and her sister Ina is standing beside it holding her doll. They were the fourth and fifth children born to Dave and Leona Wickerd. Since Clara was born in 1908, the photograph might have been taken around 1909. The family lived in the area north of Scott Road and south of Wickerd Road. Clara has descendents still living in the area. (Courtesy Loretta Eckes.)

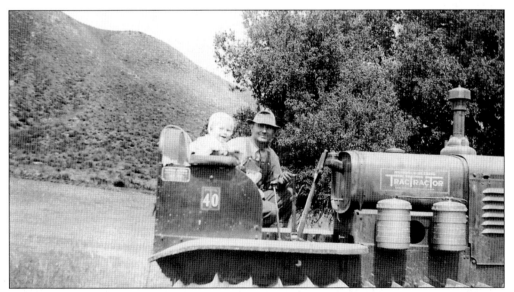

LYLE AND HANS CHRISTENSEN. Pictured here around 1937 is Lyle Christensen with his father Hans. They are sitting on an International 40 tractor in Cottonwood Canyon. The area is where Holland Road ended and Cottonwood Canyon began, which is now called Canyon Hills, and houses are replacing the farmland. His mother, Zora, might have been delivering lunch when they posed for this photograph. (Courtesy Lyle Christensen.)

**BAILEY'S ANIMALS, 1927.** Charles Bailey is holding the reins of a horse with his son Luther before his daughters and Luther's cousins take a ride. Children loved to visit the farm and ride his horse Sugar. The bottom photograph shows Luther holding the halter of a Jersey cow, his sister Leota milking it, and Ida Mae and Gladys on its back. Charles also raised pigs and all his farm animals were tame. (Courtesy Sandra La Fon.)

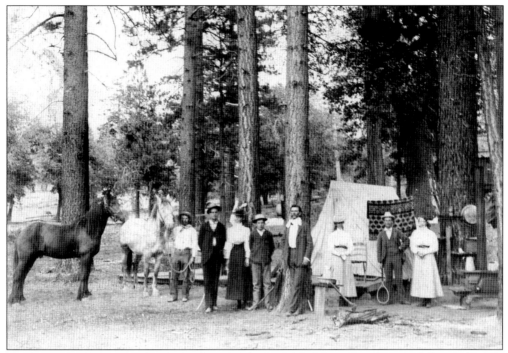

THOMAS VALLEY, 1899. The above photograph identifies the area as Thomas Valley in the San Jacinto Mountains. There is also a Thomas Mountain near Garner Valley today. The Kirkpatrick's are pictured here camping in the San Jacinto Mountains while cutting wood, and it seems to be a family affair since women are present. The man on the far right is holding a tennis racket. The date for both of these images is 1899. The bottom photograph shows a five-yoke team of oxen hauling timber out of Idyllwild. The San Jacinto Mountains was the nearest forest for wood gathering. (Courtesy Leonard Kirkpatrick Jr.)

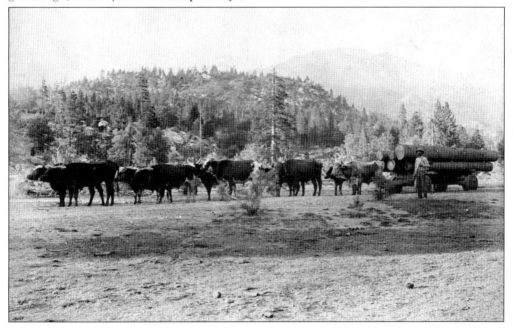

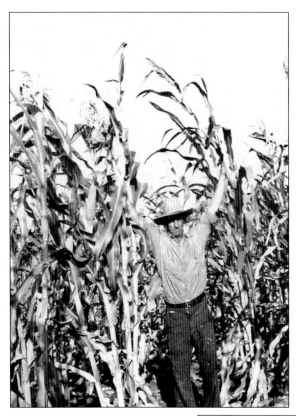

**JAY WICKERD'S CORN CROP.** Jay Wickerd dry farmed his crops, and this corn was taller than he was. Jay was the oldest son of John Wickerd, who came to the valley in 1907. He raised all types of fruit and vegetables and kept bees. The farm is still intact, and his grandson Jack Wickerd keeps an apiary of bees and grows Christmas trees. (Courtesy James Wickerd.)

**MCELWAIN'S PONY CART.** It was a happy sight in the valley to see Norbert McElwain trotting his small pony pulling a festive cart. He was taking his children, Clark and Bonny, down Antelope Road to the one-room Antelope School at the corner of Scott and Antelope Roads. In the late 1940s, he would have encountered only one or two cars on this isolated road that dead-ended at Clinton Keith Road. (Courtesy Nina McElwain.)

**THANKSGIVING AT THE BROWNS, 1913.** Pictured here, from left to right, are Rosamond, Walter, William, Margaret, Myra Kittilson, and Hazel Brown. They had Thanksgiving dinner before going out to plow the field. There were 16 horses on the farm, and they only worked six of them at once while letting the others rest for the following day. (Courtesy Rosamond Morrison.)

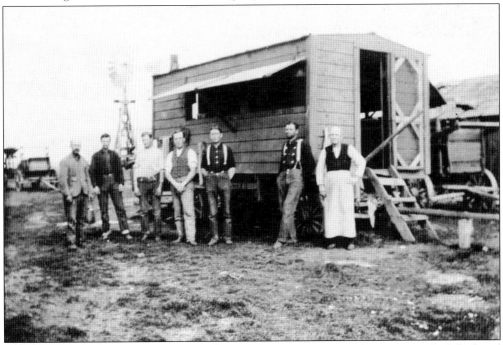

**KIRKPATRICK'S CHUCK WAGON.** All large farms had a cook and chuck wagon to feed the hired men. This photograph shows the cook in his apron and the hungry men waiting for their hearty meal, which was required for the long hours ahead. Some wagons had canvas tarps instead of a regular roof. On the smaller farms, the wife of the house fixed the meal for the men in her own kitchen. (Courtesy Leonard Jr. and Jean Kirkpatrick.)

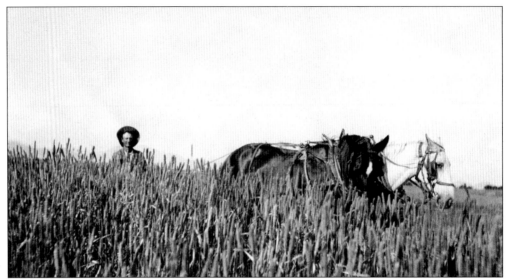

ROBERTS BARLEY CROP. John Walker is checking the barley crop on the Roberts ranch, which comes to his shoulders and almost dwarfs the team of horses. The ranch had three water springs, two cold and one warm, and was located south of Scott Road and on the west side of Briggs Road. (Courtesy Linda Brown.)

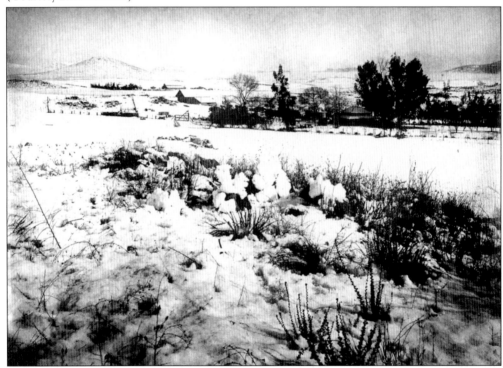

1915 SNOWSTORM. The Menifee Valley was surprised by a snowstorm on December 30, 1915, which was a wonderful scene for the children during the holiday season. The scene is the Roberts ranch, formerly known as the Emmelita ranch. The Roberts and Walker families enjoyed the unexpected snow and took many photographs, especially since Charles Roberts was a photographer. (Courtesy Linda Brown.)

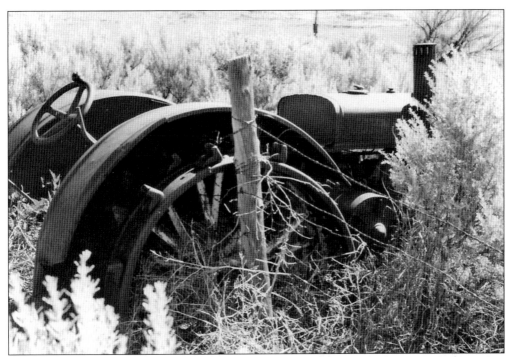

FORGOTTEN WALLACE TRACTOR. Walter Zeiders used a team of horses to pull the plow when he started farming, but in the mid-1920s, he bought this new Wallace tractor. It served him well into the mid-1930s, when it was retired to sit among the other unused machinery on his ranch. Such was the fate of many tractors. (Courtesy Merle Zeiders.)

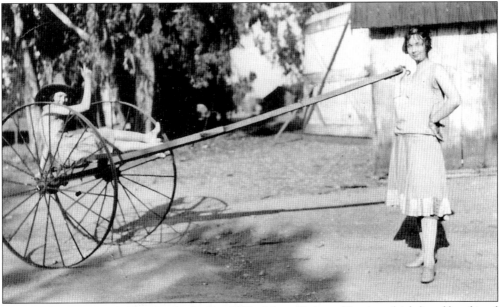

MARIE HARRISON AND FRIEND. In the late 1920s, Marie Twinem Harrison (right) and her friend are enjoying a little fun by playfully posing with the hay rake in front of the barn (back right). The structure is still standing and in good condition on the Harrison ranch at the southeast corner of Scott and Antelope Roads. (Courtesy John R. Harrison.)

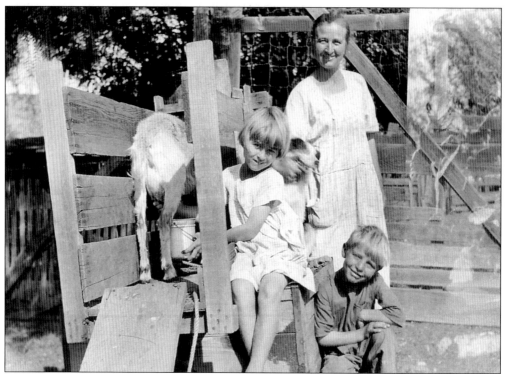

**ALICE ROBERTS MILKING THE GOAT.** Alice Roberts (left) is milking a goat while her mother, Callie, and brother Lerner watch. The goat is in a stanchion so it will not knock the bucket over or jump around while she is milking. Farm children, both boys and girls, had many different chores to perform. (Courtesy Linda Brown.)

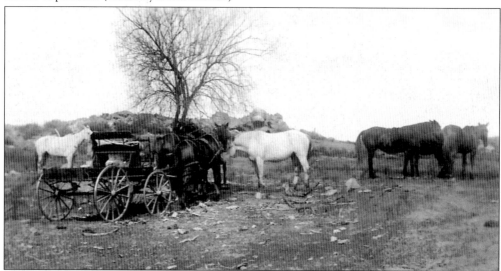

**HORSE-DRAWN WAGON.** These horses are resting under a tree on a hot summer day; perhaps the occupants have gone for a walk or are on a picnic. The team is tied to the tree, but the other horses in the pasture roam free. The rocks in the background were a favorite place to explore. Looking through the family collection, it is evident that the photographer liked this background. (Courtesy Linda Brown.)

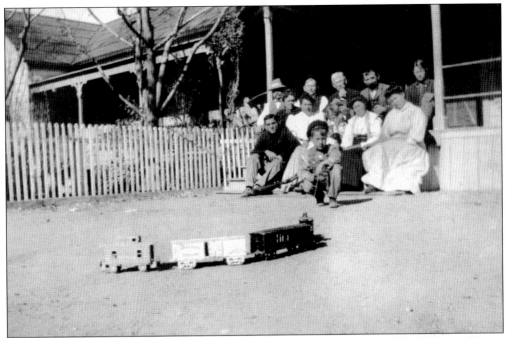

NEWPORT CHRISTMAS PHOTOGRAPH. These adults, sitting on the steps of the Newport House, are watching a youngster admire his new train. William Newport is in the back row at left. (Newport family album.)

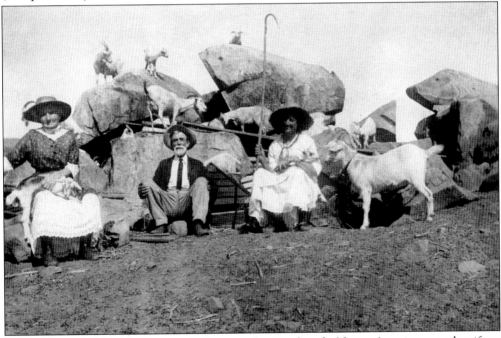

INDIAN GARDEN ROCKS. These rocks were a gathering place for Native Americans, and artifacts discovered here on the Roberts ranch have all disappeared into private collections. Emma, Oliver, and Callie (right) are resting while the goats romp on the rocks, as they like to climb up to the highest point. Crooks were used to catch the goats if necessary. (Courtesy Linda Brown.)

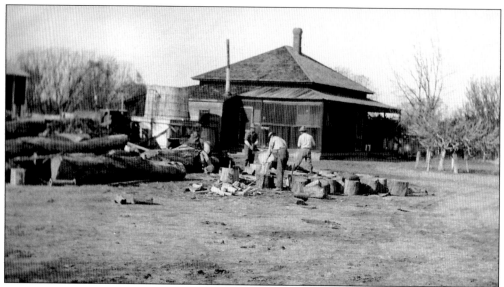

**NEWPORT RANCH SOUTH.** Firewood was a necessity on all farms, and these men are cutting wood on the South Newport ranch, located in French Valley near Lake Skinner. William Newport did not keep this ranch very long. Notice the large logs they are cutting up. Two men in the back are using a crosscut saw to make smaller logs, and the man in front is splitting the wood into usable size. (Newport family album.)

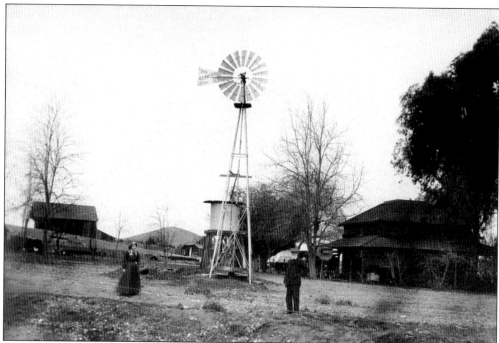

**EMMELITA VILLA AND WINDMILL.** Charles Roberts bought the farm known as Emmelita Villa, and this photograph shows it in the early days. Notice the windmill and water tower in the middle. The windmill pumped water from the well up into the water tank where it would be available to be retrieved by buckets. Later they piped it into the house, and the flow of gravity would furnish them with running water. (Courtesy Linda Roberts.)

# Three

# HOMES

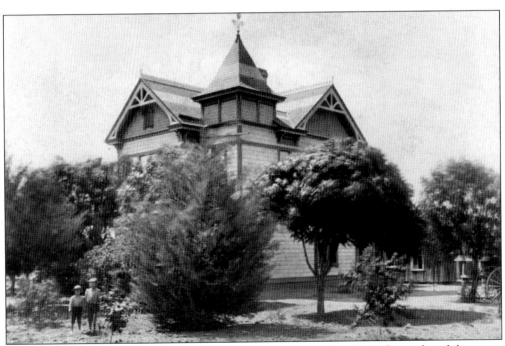

**THE KIRKPATRICK HOUSE.** This house was home to William and Callie Kirkpatrick and their nine children. Built around 1890, it reflects their southern roots. Leonard Sr., the youngest son, and his family were the last to occupy the house. It was quite a landmark in the community until the property was purchased for development, and the house was torn down. The present community of Menifee Lakes is located on the Kirkpatrick land. (Courtesy Julia Difani.)

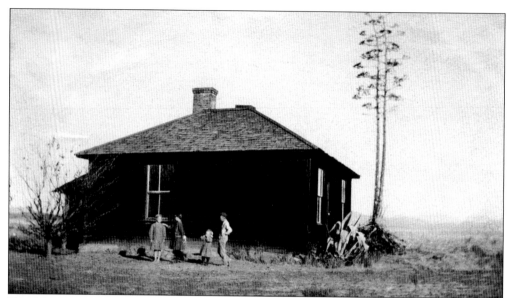

THE MICHELBACHER HOUSE. This house was located on the east side of Section 14 near Menifee Road. It consisted of four rooms with no kitchen according to Rosamond Morrison. Her parents, William and Norma Brown, lived there from 1899 until after 1904. They shortened the name to the Mike House. Three of their four children were born in the house. It was destroyed years ago, but a century plant has survived. (Courtesy Rosamond Morrison.)

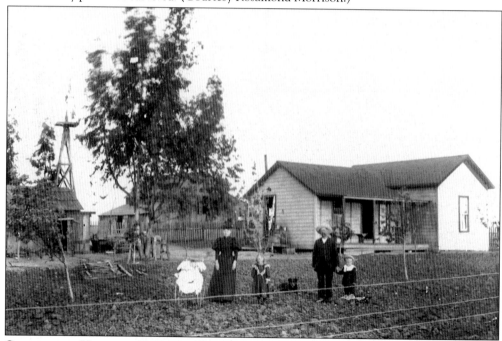

CHRISTENSEN HOUSE, C. 1897. The Christensen family, pictured here, are in front of their home located on Antelope Road between Holland and Garbani Roads. Standing in front, from left to right, are Conzada, Rosetta, Ellen, Hans Sr., and Hans Jr. The house burned down in 1919 and a new one was built at the same location. Hans Jr. and his family lived there after his father's death. The house was enlarged in 1936. (Courtesy Lyle Christensen.)

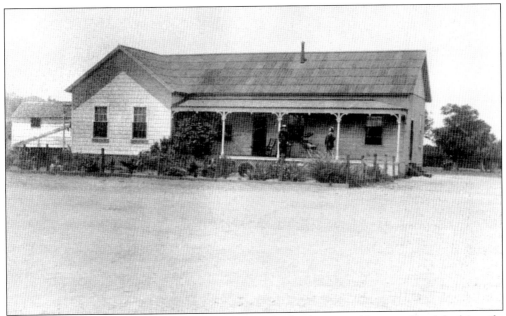

NEWPORT HOUSE, C. 1887. William Newport built this house on Newport Road for his wife, Mary, and their five children, who were all born there. It was their home for over 40 years. Later he planted 10 acres of fruit trees and laid out grounds adorned with shade and ornamental trees, hedges, walks, and drives, making the homestead one of the most attractive in the valley. (Courtesy Mary Antha Harnish.)

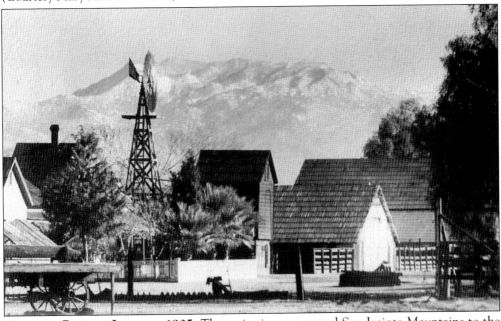

NEWPORT RANCH, JANUARY 1905. The majestic snowcapped San Jacinto Mountains to the east make a beautiful backdrop for the barns and outbuildings that make up the Newport ranch. Newport stored the grain harvested from his large acreage in the barns. He owned 120 full-blooded horses and raised prize Berkshire hogs. There was a cookhouse for the 30 men he employed. (Newport family album.)

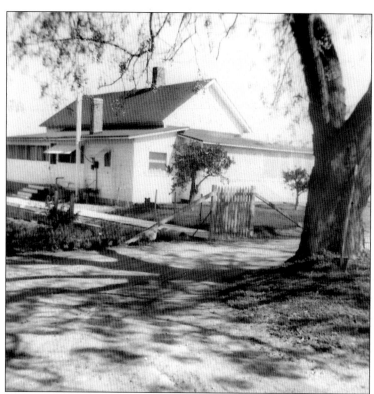

**DRAKE AND BOURIS HOUSE.** Joseph and Harriet Drake built the old Drake house in 1888. Lumber for the house and buildings were hauled down from Idyllwild using teams of horses pulling the lumber on sleds. Hercules and Betty Bouris bought the house in 1951 and made many changes to the original homestead through the years. They raised their children there and began farming wheat. (Courtesy Betty Bouris.)

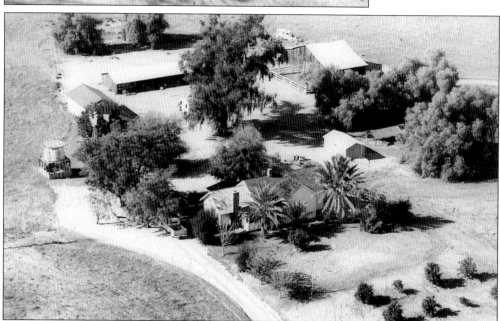

**OVERVIEW OF THE DRAKE RANCH.** This aerial photograph shows an overview of the old Drake place on Zeiders Road. The Drake family came here in 1887 from Lawrence County, Pennsylvania. The parents, Joseph and Harriet Drake, brought their family of four children with them. Later Elluard (a son) and wife Elizabeth owned the farm and operated an egg ranch. Hercules and Betty Bouris bought the 80-acre farm in 1951, and Betty still resides there. (Courtesy Betty Bouris.)

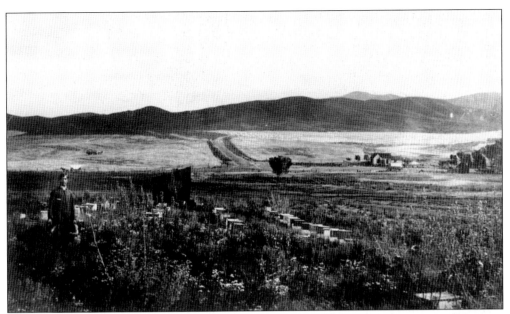

HENRY EVANS RANCH, 1910. This ranch was 100 acres and located at the corner of Newport and Goetz Roads. Salt Creek is beside the lone tree, located in the middle of the photograph. Henry's father, Thomas J. Evans, was living in San Bernardino when he purchased the ranch in 1891. His journal states, "I swapped house and lot on corner of H and 10th street to M. Easton with $250 note for their 100 acre farm where Henry lives." (Courtesy Elinor Martin.)

ENLARGEMENT OF EVANS HOUSE. A close-up of the house shows the chuck wagon in the foreground. Hobos were always welcome to a meal, and they made marks on fence posts nearby so others would know it was a good place for a meal or some work. The present-day location would be at the north end of White Wake Drive in Canyon Lake. He moved to another house at the corner of Murrieta and Garbani Roads and spent the rest of his life there. (Courtesy Elinor Martin.)

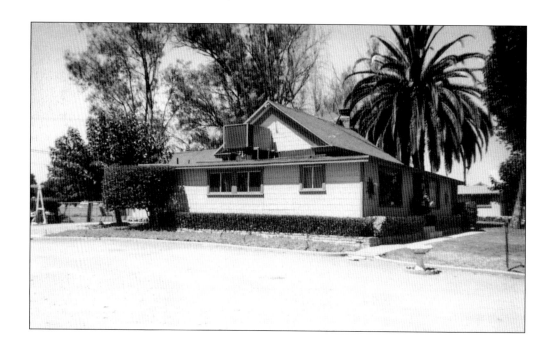

**JOHN HARRISON HOUSE.** This house and barn are the original buildings that the Kohlmier family built in 1900. John H. Harrison and his heirs have lived on the ranch since c. 1911. John R. Harrison and his wife, Jan, currently live at the residence. Their son Dick Harrison also has a home on the property. It is located at the southeast corner of Scott and Antelope Roads. (Courtesy John R. Harrison.)

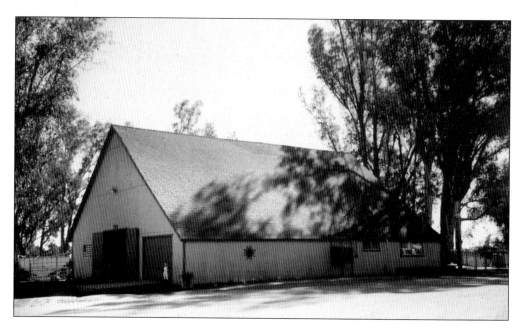

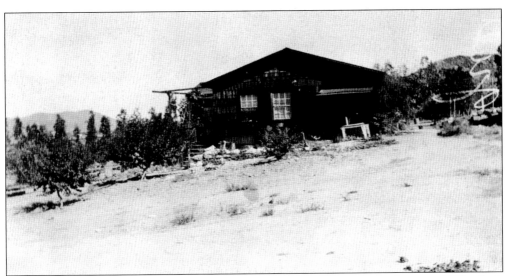

JOHN MCGRATH HOUSE, 1914. The John McGrath family moved into this house in 1912, which was located at the corner of Newport and Briggs Roads. John's brother built a house at the end of Newport Road before returning to Santa Barbara and telling John he should move to Menifee, as the dry climate would be good for his health. It is not clear if this was the same house that John's brother built. (Courtesy Herbert Christensen.)

THE BAXTER HOUSE. The Baxter house is situated on the present-day Pinto ranch, located on Briggs Road about a mile south of Scott Road. Built in the early 1900s, it serves as a bunkhouse for children attending the summer horse camps. A stream runs through the grounds, and the many trees give a cool setting for camp activities. It is off the beaten path even today, giving a person an opportunity to escape to a real retreat. (Courtesy Marcie Stimmel.)

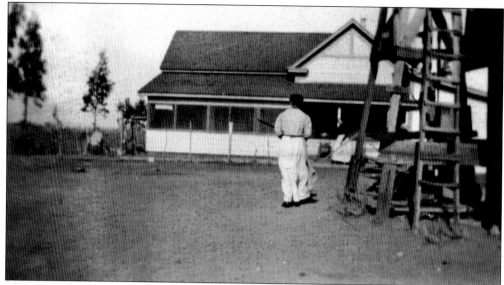

WILLIAM H. BROWN HOUSE. The Brown family moved to this house on the Timberculture Claim, where Rosamond was born, at the corner of Garbani and Antelope Roads. The house sat on a knoll, and the large barn on the east side was two levels. The windmill pumped water into a tank on top of the tower and they were able to have running water. Electricity did not come to the valley until 1946. (Courtesy Rosamond Morrison.)

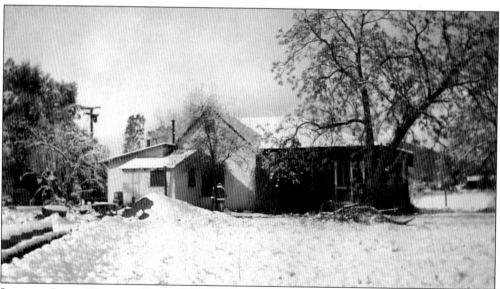

JOHN OR JOYCE WICKERD HOUSE. John Wickerd came to Menifee in 1907 and purchased 160 acres north of Scott Road and east of Murrieta Road. Other family members soon arrived and settled on the property with their families. Later Joyce, the second son, and his family arrived and moved into this house. Four generations have since called it home. The unusual snow in 1949 made a beautiful scene. (Courtesy Robert Wickerd.)

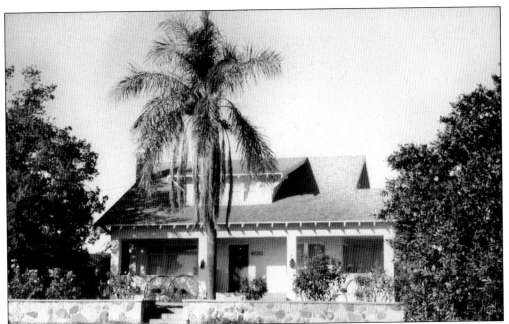

WALTER ZEIDERS HOUSE. Walter Zeiders built this house in 1933. It was two stories with six bedrooms, a living and dining room, a breakfast room, a kitchen, and one-and-a-half baths. The lumber came from the old Val Verde School. The extra bedrooms were for the hired men, and teachers at the local school boarded there for nine years from 1934 to 1943. The extra rent offset the cost of the hardwood floors. His grandson Gary and his family live there today. (Courtesy Merle Zeiders.)

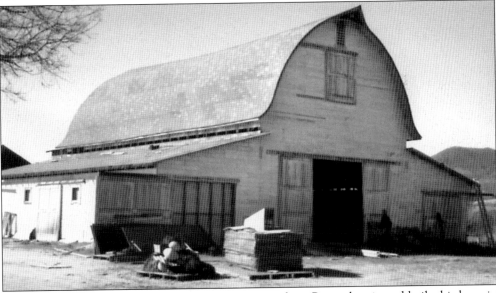

PENNSYLVANIA DUTCH BARN. Walter Zeiders came from Pennsylvania and built this barn in 1938. The lumber for the framing and the redwood siding also came from the old Val Verde School. Lumber was soaked in water to form the curve for the roof. Sacks of grain were stored in the east wing and center, sometimes reaching 25 feet high. The west wing was reserved for feeding horses and cows. (Courtesy William Zeiders.)

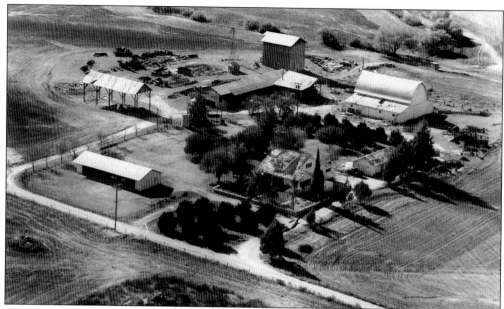

AERIAL VIEW OF ZEIDERS RANCH. The residence of the ranch is in the foreground and a garage at the left corner. The tall building at the top of this photograph is a granary that could hold 600 tons of grain in six sections. An elevator carried the grain from the pit up into the bins. There was also a complete machine shop next to the granary. The ranch was part of the 240 acres Walter had acquired by 1932. (Courtesy Merle Zeiders.)

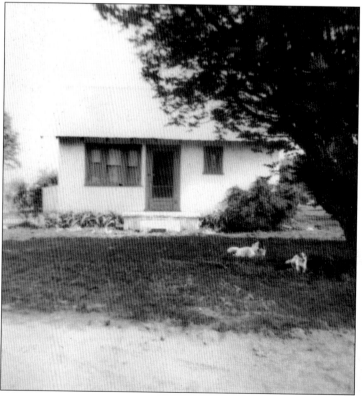

GEORGE DEWEY EVANS HOUSE. George and Leta Evans lived in this house from 1925 to 1950. It was moved from Coop Station in the Railroad Canyon area to its location on Antelope Road, two miles south of Scott Road. Originally it consisted of four rooms, but later it was enlarged to seven rooms. The total area was approximately 850 square feet. The house was moved to San Jacinto in 1950, and a new one was constructed. (Courtesy Elinor Martin.)

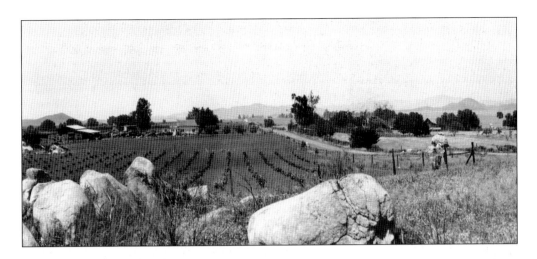

THE BOURIS BROTHERS RANCH. This photograph, taken in 1929, looks north on the old Antelope Road. The vineyard is visible in the foreground. They also grew walnuts, oranges, figs, and peaches in their orchards, which they shipped three days a week to the Los Angeles produce markets. They also purchased other produce and resold it in their Elsinore store, Burnhams Market in Murrieta, and to the Murrieta Hot Springs Hotel. George, his wife Mary, and Sam processed olives and made feta cheese from milk their cows produced. The bottom photograph shows the house bought by George, Sam, and Ted in 1922. Customers used this driveway off Antelope Road to purchase their produce and wine grapes. (Courtesy Betty Bouris.)

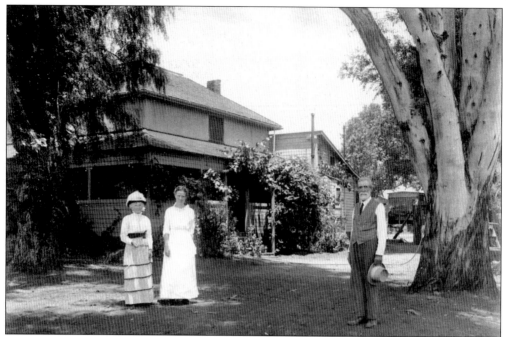

**THE ROBERTS HOUSE.** Charles Roberts bought this house, once known as the Emmelita Villa, around 1890. He brought his bride, Callie Walker, here in 1915. Three springs were on the property, one hot and two cold. It was located on the west side of Briggs Road about a mile south of Scott Road and now is one of the ranches owned by the Anheuser-Busch Company. They raise Clydesdale horses and show them in parades and fairs. (Courtesy Linda Brown.)

**THE WRIGHTVIEW RANCH.** Paul Wright is pictured here in front of his parent's house. Their road was a mile through the hills that was originally built with a pick and shovel. Edward and Christine Wright first erected a board-and-batten frame building. Later a concrete roof and floor were added and the outside was veneered with native stone mined from Crowfoot Mountain. The walls of the house were two- to three-feet thick. (Courtesy Paul Wright.)

**STANLEY MCGRATH HOUSE.** Stanley built this house himself with the help of a friend by the name of Gibbs. It was finished in 1933, and he and wife, Belle, hosted a party to show it to friends. The house was located on Antelope Road next to Leta Evans's (Belle's sister) home. It is still standing today and easy to recognize by its unique architecture. Four generations of McGraths have lived in the house. (Courtesy Elinor Martin.)

**CHARLES BAILEY HOUSE.** Charles "Charlie" Bailey built this house using native rocks for the fireplace. He collected them as he cleared the fields for planting. Charlie and Laura came to Menifee in 1915 and lived there the rest of their lives. Their home was always open to friends and family. (Courtesy *La Laguna Review*.)

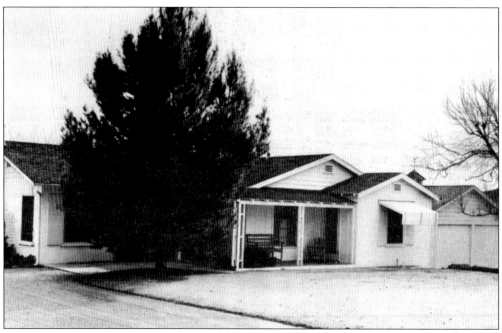

LILLIAN DIVINE'S HOUSE. The home of Lillian Divine and her family was located at the south end of Antelope Road, across from the McElwain ranch, which was formerly owned by Robert Carlson and his wife. Lillian and her children, Louise and Gerald, moved here in 1946 from Monterey Park. Over the years, the original house was enlarged, decorated, and landscaped. It is still standing today. (Courtesy *La Laguna Review*.)

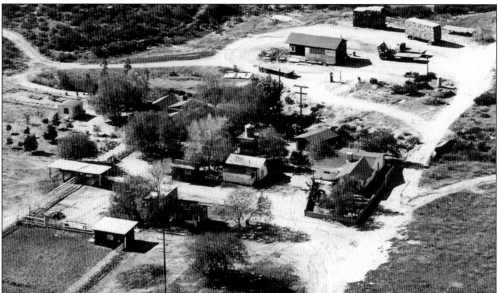

VIEW OF MCELWAIN RANCH. This is an aerial view of Norbert and Emily McElwain's Cackle Canyon ranch on Antelope Road, just north of Clinton Keith. They came to Menifee Valley in 1947 and operated a poultry business here. They arrived from Compton, where they owned a grocery store called Everybody's Market. The 20 acres is now part of a large developing shopping center by the name of The Orchard. (Courtesy Nina McElwain.)

# Four
# FARMING AND COMMERCE

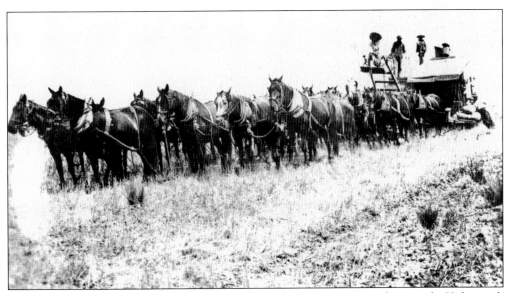

**KIRKPATRICK RANCH HARVEST.** Horses are pulling a harvester as it cuts wheat on the Kirkpatrick ranch. This type of work was done from the late 1890s to the 1930s, before tractors took the place of teams of horses. A large part of farming was in the feeding and care of the many horses needed to pull the machinery. (Courtesy Julia Difani.)

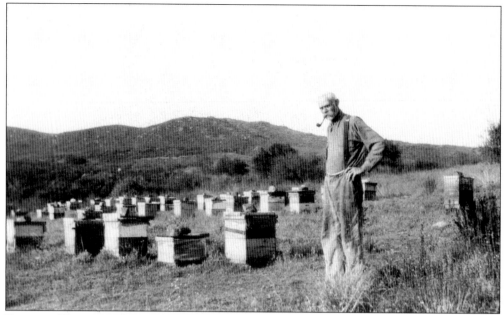

**RICHARD HARRISON, BEEKEEPER.** Richard and Delia Harrison lived on a ranch in the southern part of Menifee Valley. He was a tanner and taxidermist and kept an apiary of bees. Some of the hides he tanned were still in existence in the 1990s. His ranch was located in the area now known as the Greer ranch in Murrieta. (Courtesy John Harrison.)

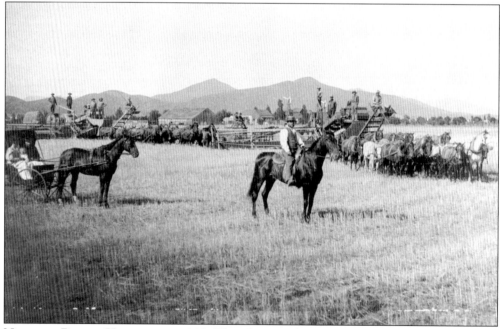

**NEWPORT RANCH HARVEST, C. 1905.** This photograph shows the September wheat harvest on the Newport ranch in Menifee around 1905 or 1906. William Newport is on horseback and his wife, Mary Catherine, is in the carriage with her relative from England, Polly Denson. The harvesting is accomplished quickly with the aid of his four 30-horse combined harvesters. (Courtesy Mary Antha Harnish.)

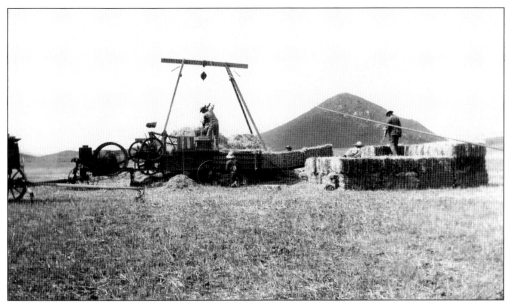

BAXTER POWER PRESS, 1912. The location of this photograph is on the Baxter ranch, south of Bell Mountain. A large, stationary gas-fired internal combustion engine powers this power-press baler. The baler is hand-fed by a crew of men using pitchforks. The greatest change in farming technology was the gas engine, which was introduced in the early 1900s. It was a boon to farmers, who previously used backbreaking hand labor for the many tasks on the ranch. (Courtesy Rosamond Morrison.)

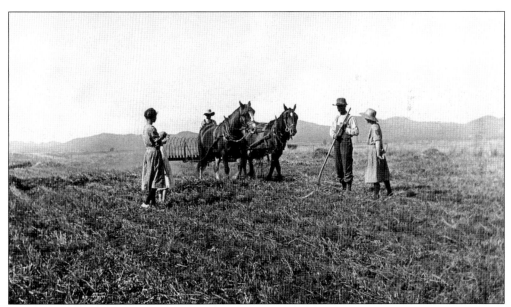

RAKING SUDAN GRASS, 1916. This farm scene shows father William Brown on the hay rake with, from left to right, children Margaret, Rosamond, Walter, and Hazel. They are raking the hay into rows to dry before being stored in the barn. The Sudan grass provided feed for the horses. The horses were as much a part of the family as their dogs and cats and all were given names. Rosamond can still remember their names. (Courtesy Rosamond Morrison.)

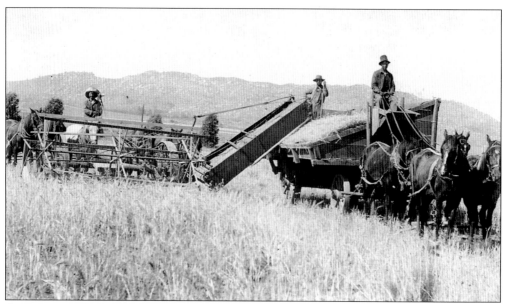

CHRISTENSEN HEADER WAGON. Farming in Cottonwood Canyon, this hired hand is driving a team of horses pulling the wagon. Hans Jr. is on the deck next to the white horse. Horses push the cutter, a large wheel runs the belt, and straw travels up the belt for Hans Sr. to pitch into the wagon. (Courtesy Lyle Christensen.)

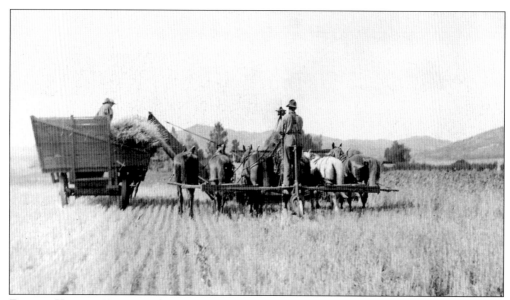

ZEIDERS HEADER WAGON. This photograph shows Walter Zeiders driving his team of six horses. After the wheat is cut, it is sent up the draper (belt) into the wagon pulled by two horses. The stacks go to a stationary harvester where the grain is threshed and put into sacks and stored. (Courtesy Merle Zeiders.)

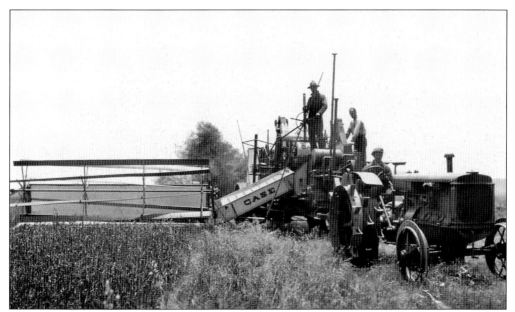

HARRISON'S CASE HARVESTER. This 1929 Case tractor is pulling a Case harvester on the Kohlmier ranch southeast of Scott Road on Antelope Road. Ben Kohlmier is driving the tractor and John H. Harrison is working on the harvester with an unidentified helper. Farmers in the Menifee Valley attended equipment trials and always tried to keep up with the latest technology. (Courtesy John R. Harrison.)

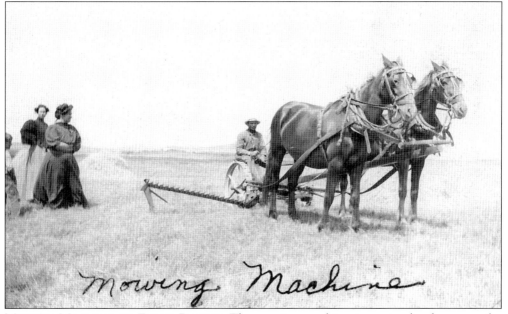

MOWING MACHINE ON EVANS RANCH. The mowing machine is cutting borders around a grain field before the start of harvest. The women have probably brought lunch to the field so the men will not have to stop and return to the house. Farmers put in long days while the weather was favorable. The field was located at the east end of present Canyon Lake. (Courtesy Elinor Martin.)

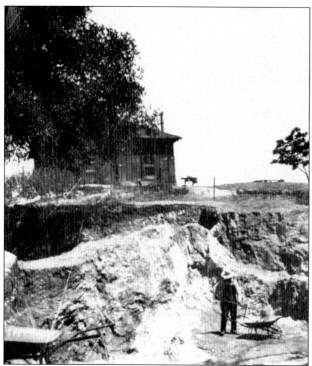

FELSPAR SILICA MINE. David Wickerd first lived in the house pictured in this photograph. While digging a well near the tree, he discovered a vein of silica ore and later sold the property. This photograph shows the start of the hand-dug mine, which was 100 feet deep with a 300-foot lateral that extended towards Scott Road. It was located north of Scott Road near Tucker Road. (Courtesy Lorraine Eckes.)

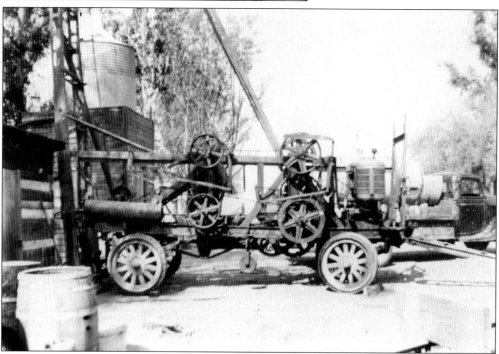

WATER WELL RIG. Cleo Judson owned this rig and drilled wells for many valley residents. Charlie Bailey was a water witcher and used his talent to locate where to drill the wells. He used a forked willow stick when he did the witching. When held upright, the stick bends slowly downward when it locates water. Not everyone had this talent. (Courtesy Merle Zeiders.)

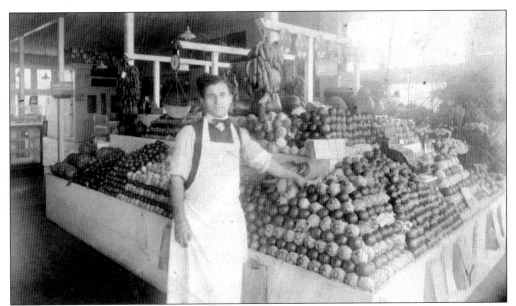

BOURIS BROTHERS PRODUCE MARKET. Ted Bouris, pictured here, managed the produce market at the Alpha Beta Store in Elsinore. The Bouris Brothers marketed much of the fruit and vegetables grown on their farm in Menifee. Later Ted became the sole owner and operated it with his wife, Anastasia, and children Hercules, Helen, and John. They sold and retired to San Diego in 1951. (Courtesy John Bouris.)

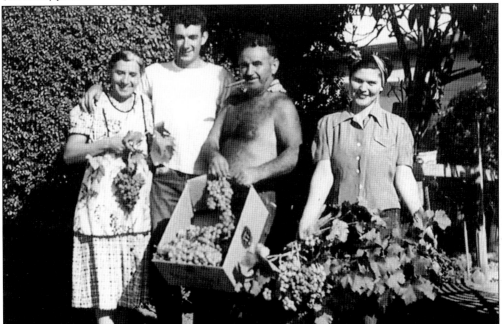

THE GRAPE HARVEST. Pictured here, from left to right, are Mary, Hercules, and Sam Bouris and a friend from Los Angeles. They are celebrating the grape harvest in 1946 at the Bouris brothers farm located on Antelope and Keller Roads. Friends and family all pitched in to cut grapes from the vines, pack them in boxes, and truck them to the Los Angeles Central Market. (Courtesy Betty Bouris.)

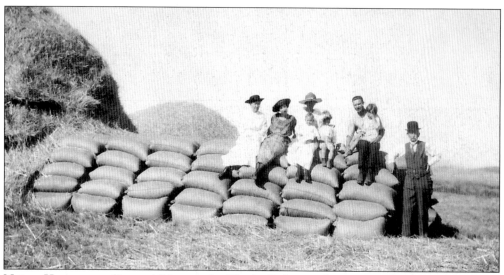

NEWLY HARVESTED GRAIN. Visitors to the Charlie Bailey ranch pose on sacks of newly harvested grain. Before the advent of the self-propelled combine, grain went into burlap bags and was hand-stitched by the man riding on the harvester. Then the 100-pound sacks were loaded onto wagons for the trip back to the storage area. (Courtesy Sandra La Fon.)

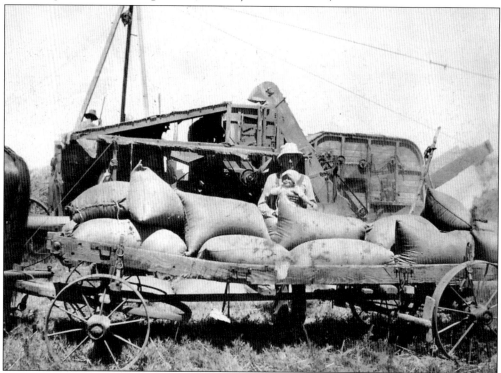

CHARLIE BAILEY'S HARVEST. The stationary harvester in the background is being hand-fed sheaves of wheat by a crew of men. (Sheaves of wheat are stalks or straw with the grain still attached). The sheaves, mowed in an earlier operation, are stacked in the field by hand. The harvester shakes the grain out and processes it through a chute into waiting sacks where they are stitched and loaded onto the wagon. (Courtesy Sandra La Fon.)

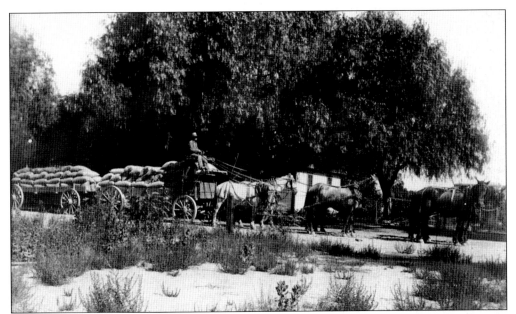

**KIRKPATRICK GRAIN WAGON.** This team of six horses is pulling two wagons loaded with sacks of grain. They are heading from the field to the Kirkpatrick barns for storage. It was hot and dirty work with no air-conditioning. Harvesting season was from July to September, which was the peak of the hot summer months. (Courtesy Leonard Kirkpatrick Jr.)

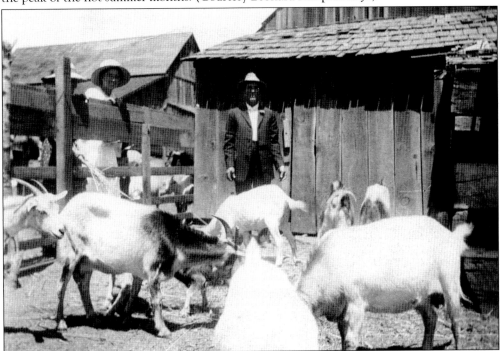

**THE ROBERTS WITH THEIR GOATS.** Charles and Callie Roberts raised goats on their ranch on Briggs Road. Since their children were allergic to cow's milk, it was a necessity. Bartering was a way of life in those days, and they traded goat's milk with other families to get commodities they did not produce. (Courtesy Linda Brown.)

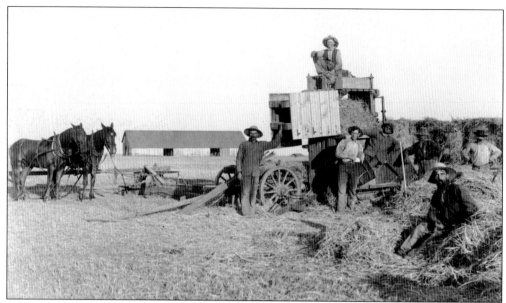

HAND-POWERED BALER. A crew of six men is operating this early hand-powered baler on the Roberts ranch on Briggs Road, south of Scott Road. The dried hay is hand packed into the wooden bale mold, which is tied with twine or wire, removed, and carried to a nearby wagon. The hay was then carted to the barn to be unloaded into storage. This was an ingenious way to make a bale but was labor intensive. (Courtesy Linda Brown.)

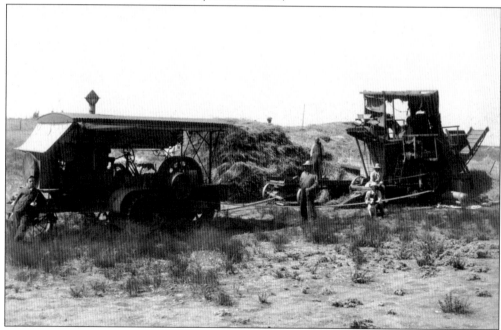

HAY BALER ON ROBERTS RANCH. This newer version of a hay baler, powered by a 1913 Holt 75 gas tractor, could compress bales and kick them off a back ramp onto a waiting wagon. A belt attached to the engine drives the baler. It took several men to toss the hay into the bale molds and tie them with wire. There is a canvas shade to protect the men from the sun. (Courtesy Linda Brown.)

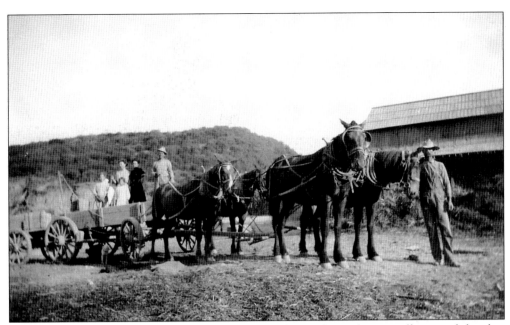

**ALBERHILL CLAY PITS.** One of the Ferrell men is standing in front of a team of horses, while other members of the family are standing in the wagon. At the time, he was hauling for the Alberhill clay mines in the early 1900s. The farmers often took their equipment and worked other places to make ends meet. (Courtesy Elinor Martin.)

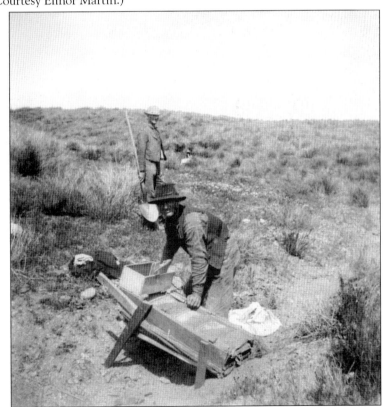

**WALKER BROTHERS PROSPECTING.** Pictured in the foreground is John Walker with his brother Claude doing a little prospecting for gold. The sluice box is sitting in a small, dry creek bed where dirt can be sifted and promising rocks extracted. Samuel Walker, father to John and Claude, spent his life mining and was not very successful. (Courtesy Linda Brown.)

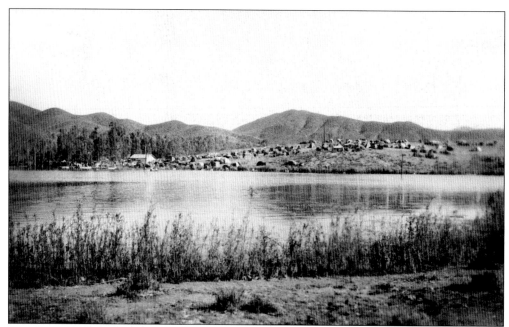

EVANS FISH CAMP. Evans Fish Camp on Railroad Canyon Reservoir opened in May 1937. Temescal Water Company constructed a dam on the San Jacinto River in 1929 and created the reservoir. They owned the lake and leased the concession to the George Dewey Evans family. Not expecting such a large crowd on opening day, George had to cut the fences of his pasture to allow cars to reach the lake. This first building acted as an office and housed a tent on the back for sleeping. They had seven boats to rent to customers, but most of the anglers fished from the shoreline. Another building was necessary and one was constructed the following year along with several cabins. The buildings were moved in 1940 to another location where the lake was deeper. On opening weekend, 1,000 people were enjoying the lake. (Courtesy Elinor Martin.)

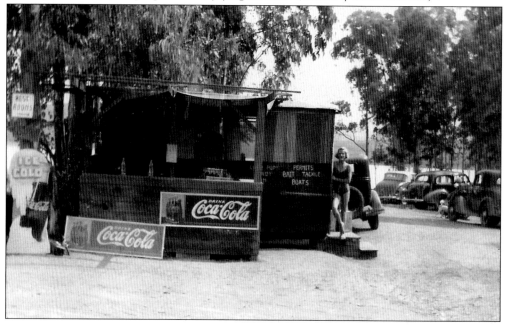

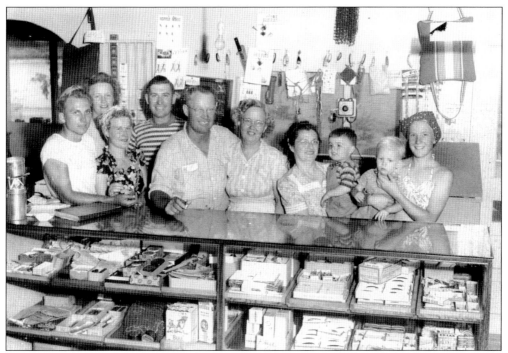

CONCESSION AT RAILROAD CANYON LAKE. Pictured here, from left to right, are John and Darleen Kirkland, Alpha and Ray Schekel, Dewey and Leta Evans, cousin Minnie and Darrel King, David Kirkland, and Elinor Evans. Fishing permits, boat rentals, and bait and tackle could all be purchased at this counter. A small café housed in the same building was available for breakfast and lunch. (Courtesy Elinor Martin.)

THE WINCHESTER MARKET. Markets in the early years were rare and residents traveled to Perris, Elsinore, or Winchester for supplies. This photograph shows Hans and Zora Christensen beside the market in Winchester. It was located on the southeast corner of Winchester and Simpson Roads and no longer exists. (Courtesy Herbert Christensen.)

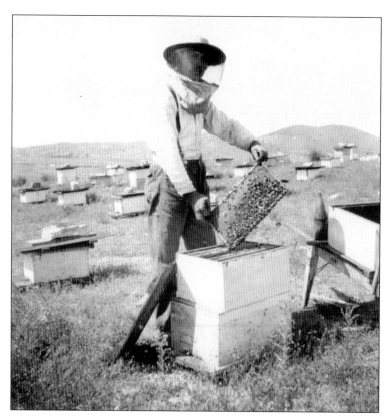

**BEEHIVE FRAME.** Charles Roberts is displaying a frame of honey with bees still on it. Notice the smoker on the right of the photograph. When the frame is full of honey, the wax cap is trimmed off and the honey is extracted. Using centrifugal force, the honey flows out and the frame is then reinserted into the hive for the bees to fill again. (Courtesy Linda Brown.)

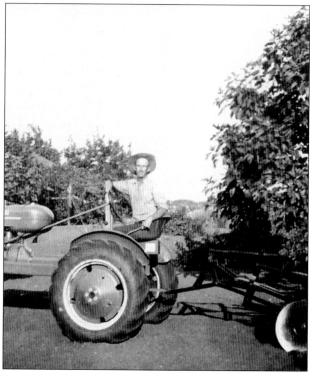

**JAY WICKERD'S NEW TRACTOR.** Jay Wickerd was the oldest son of John and Luella Wickerd. He came to the valley in 1907 and bought his own farm in the 1920s. It was 48 acres on the northwest corner of Bradley and Scott Road. Fruit trees and other produce grew on the farm. He drove the Perris High School bus for 17 years. Jay and his wife, Mildred, had two sons, James and Gale. (Courtesy James Wickerd.)

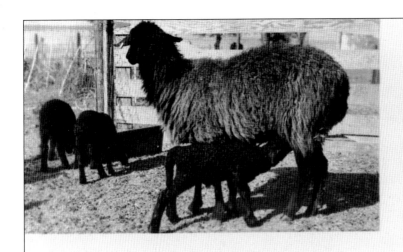

KARAKUL FUR FARM

**KARAKUL FUR FARM.** This new business introduced into the Menifee Valley in the late 1940s did not last too many years, but residents were fascinated with this different breed. The Karakul, native to central Asia, was introduced into the United States between 1908 and 1929 for pelt production. They were also a source of milk, meat, tallow, and wool, a strong fiber that could be felted into fabric or woven into carpeting such as Persian rugs. The Christmas card at the top is a close-up of the ewe and her lambs. When born, the lamb's fleece is coal black with wavy curls. As it grows, the curls open and the color starts to change. The fleece comes in a variety of natural colors. The bottom photograph shows the sheep coming down the lane toward Newport Road from their corrals on property now known as the Audie Murphy ranch. (Courtesy Elinor Martin and Lyle Christensen.)

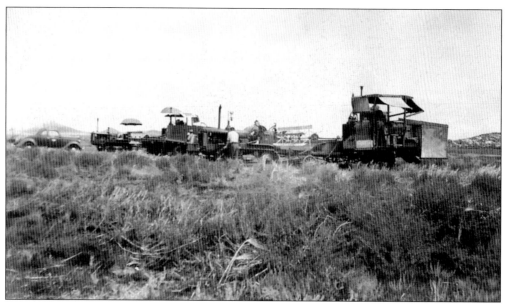

**INTERNATIONAL HARVESTER AND TRACTORS.** These two TD-35 and TD-40 tractors are pulling an International Harvester in Christensen's field near Garbani and Leon Roads. Comfort was beginning to be a concern, so umbrellas protected drivers from the heat in the summer. Herbert Christensen said it was "plain old hot work." The Dodge car at left belongs to his brother Clyde. (Courtesy Lyle Christensen.)

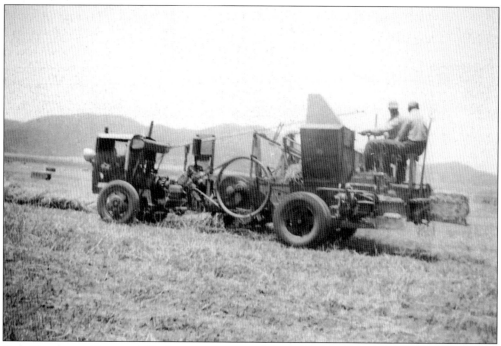

**SELF-PROPELLED BALER.** A Dodge engine powered this self-propelled Minneapolis Moline two-wire bailer. A Mr. Singer in Perris built the machine. Leslie and Merle Zeiders grew 100 acres of irrigated alfalfa and baled it with this homemade machine they named "Leaping Lena." (Courtesy Merle Zeiders.)

TEAM OF HORSES AND HARROW. This harrow, or spring tooth, was used to break the soil on newly planted fields where the soil had crusted over due to light rains that dried the ground too quickly. This team is working on the Evans ranch near Garbani and Evans Roads where the Menifee Elementary School is today. Henry Evans planted apricot trees in 1912, which are seen here in the background. (Courtesy Milton Beall.)

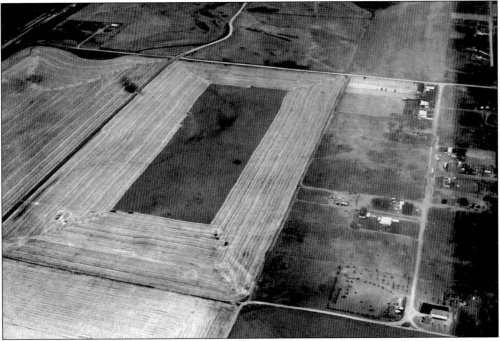

AERIAL VIEW OF HARVESTING. This photograph shows five self-propelled harvesters cutting wheat around a field. Self-propelled harvesters were introduced to the country during World War II, when more food was needed and men were leaving farms to work in the defense industries. One man could handle a harvester, a job that had taken several men with the old pull machinery. (Courtesy Betty Bouris.)

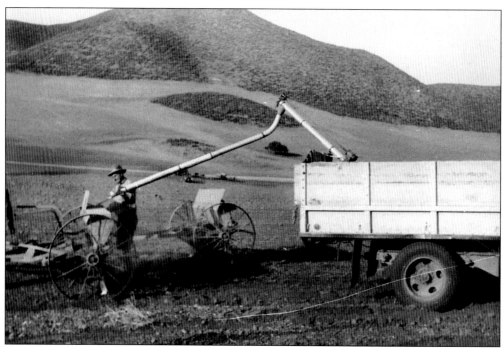

PATENTED DRILL FILL. Christensen Farms patented this drill fill, and it is still in use today. Before farmers before would dump the grain sacks by hand into the planter. This new piece of machinery eliminated that step and delivered the grain directly into the planter from the truck. Herbert Christensen made the first prototype and later manufactured them at Ryan Field in Hemet. (Courtesy Herbert Christensen.)

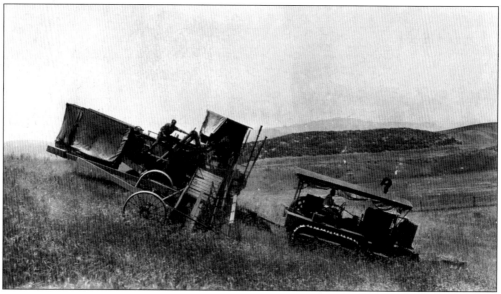

HARVESTING ON A HILL. This harvester, pulled by a track tractor, was capable of cutting wheat grown on hillsides. The Harrison ranch hand is bracing himself for the downhill ride. The farmers planted as much of their land as possible, even the hills and gullies if it was in the middle of their field. (Courtesy John R. Harrison.)

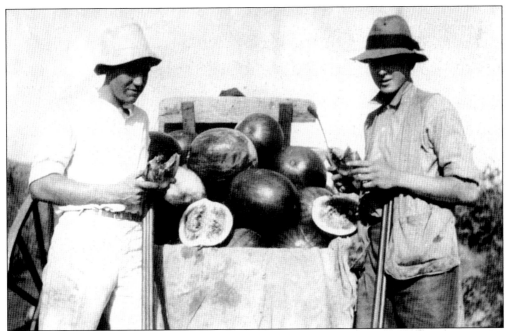

CROP OF WATERMELONS. Charlie Bailey, the first farmer to plant watermelons, had a good crop. Pictured here are two unidentified friends or relatives. Dry farming was a way of life in the valley, and no one followed his lead by growing melons commercially. His descendents say they tasted wonderful. (Courtesy Sandra La Fon.)

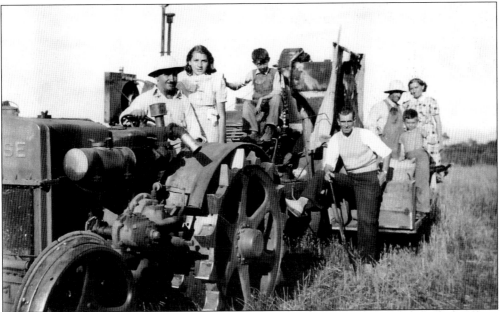

BOURIS BROTHERS FARM EQUIPMENT. The Bouris brothers owned this 12-20 cross motor Case tractor with an attached harvester. Sam and Poula Bouris are on the tractor and young Hercules is sitting on the harvester. George and Mary Bouris are in the background with visitors from Los Angeles. In addition to their commercial fruit orchards and vineyards, the Bouris's raised wheat, oats, and barley. (Courtesy Betty Bouris.)

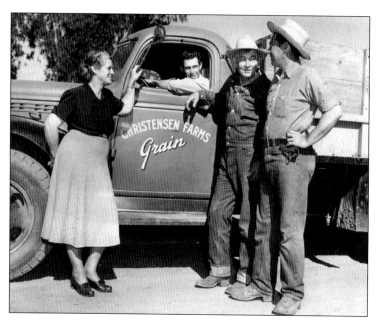

**CHRISTENSEN FARMS TRUCK, 1952.** Pictured here, from left to right, are Zora, Herbert (driving), Hans, and Clyde standing beside the 1939 Chevrolet one-and-a-half-ton grain truck. The family business was growing grain and later they manufactured and sold drill fills. An auction in June 1998 ended all the farming operations. (Courtesy Herbert Christensen.)

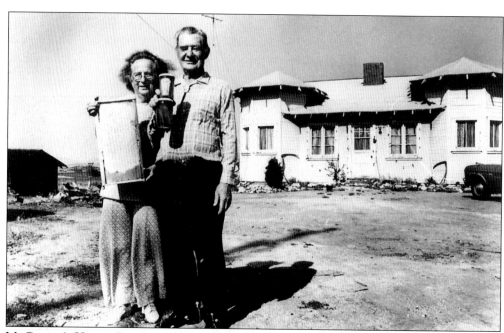

**MCGRATH'S HONEY BUSINESS.** Belle and Stanley, pictured here, are holding a frame filled with honey in the comb and a jar of honey after it was extracted. Stanley was proud of the black sage honey his bees produced and its clarity. They also operated a seasonal business of selling honey, dates, nuts, and gift packages during the holidays. This business usually occurred in the San Bernardino area. (Courtesy Ann McGrath.)

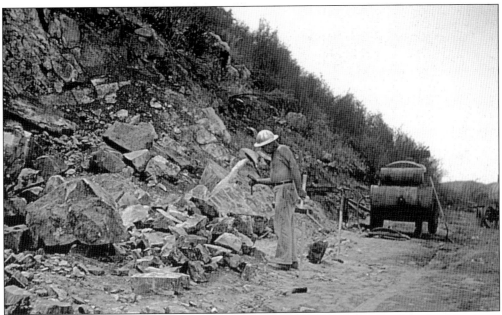

**WRIGHT'S ROCK QUARRY.** Edward Wright discovered the desert rose stone on Crowfoot Mountain, the highest peak on their property. Bob Johnson first used the stone for tombstones. When he dropped the lease, Paul Wright continued to mine it but for a different use. They used the ornamental stone on bank buildings, churches, and many homes. The most beautiful bank was the U.S. National Bank in Redlands, using 179 tons of stone for the interior and exterior. Locally the stonework appears on the Wildomar Cemetery entrance and corners, the Wildomar Post Office, the Mountain View Animal Hospital, and several homes in Elsinore. Many other commercial buildings in San Diego County used this ornamental stone. Blasting removed the stone and an air compressor broke it into smaller chunks. The quarry operated until around 1977 when the labor and red tape made it non-productive and it closed. (Courtesy Paul Wright.)

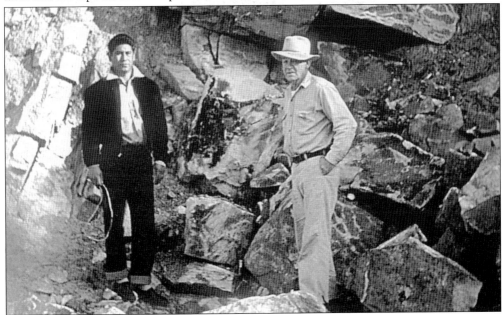

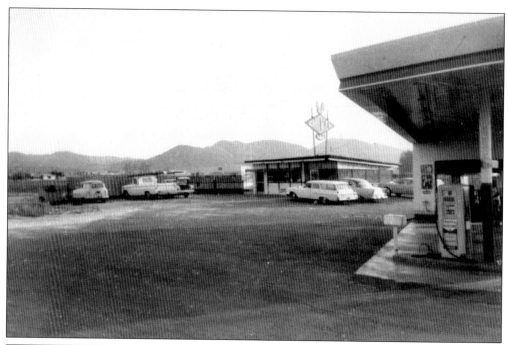

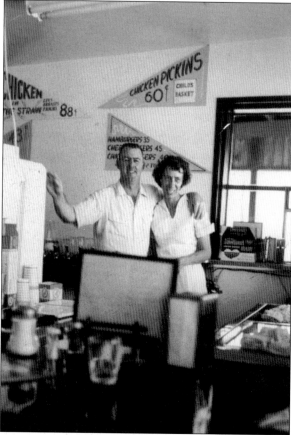

**THE CHICKEN BASKET CAFÉ.** Stan and Miami Hendry built the Chicken Basket Café on the southwest corner of Scott Road and Highway 395. Built in the 1950s, it was a welcome addition to the community. Farmers and travelers off the highway stopped to enjoy fried chicken and hamburgers. Ted and Milton Mehas operated the Richfield gas station next door. The widening of the highway in 1964 took out the businesses. (Courtesy Miami Hendry.)

**MEALS AT THE CHICKEN BASKET.** Stan and Miami put out a good meal for good prices, as seen by the sign on the wall. A person could enjoy a basket of chicken for 88¢ inside or use the takeout window. Stan did the cooking and Miami provided the friendly service. Daughters Donna and Sheri helped when they were not attending school. The family lived nearby on the same property. (Courtesy Miami Hendry.)

# Five

# Descendents and Other Residents

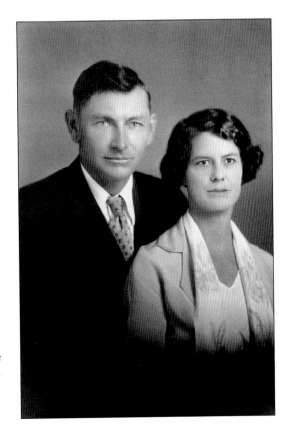

**Hans and Zora Christensen.** Hans (1894–1975) married Zora (1896–1995) in 1917 in San Bernardino, California. He was born in Menifee and she in Santa Barbara. Hans attended high school in Elsinore and boarded with the local butcher. They made their home on Antelope Road in his parent's house and raised four children: Clyde, Herbert, Christine, and Lyle. They farmed and accumulated large acreage that they eventually sold to Del Webb. They built a new home in Cottonwood Canyon off Holland Road in 1968 and lived there until their deaths. Both were always active in the community and belonged to several clubs. Hans had perfect attendance in 48 years of membership in the Lions Club. (Courtesy Herbert and Lyle Christensen.)

**THREE CHRISTENSEN CHILDREN.** The first three children born to Hans and Zora Christensen were Clyde, Herbert, and Christine, pictured here from left to right. Clyde married Eileen, resided in Hemet, and was in charge of the business end of the farming. Herbert married Kathryn of Hemet, and they still reside in the valley with their family; his interest has always been farming. Christine married Dolph Hill and moved to Petaluma, California. (Courtesy Herbert Christensen.)

**LYLE CHRISTENSEN, C. 1937.** Lyle Christensen was born in Menifee, still resides there, and lives on property once owned by his grandmother's family, the Hollands. The stroller pictured here is still in his possession, but in great need of paint. His hobby is restoring antique cars, and he has many to work on. One of his successes is his grandfather's 1915 Model T Ford delivery truck. (Courtesy Lyle Christensen.)

**CHESTER AND ROSAMOND MORRISON.** Chester was born in Kansas, came to California in 1939, and met Rosamond Brown at a dance. They married in 1941 and started farming in 1946. He spent 53 years as a trustee for the Menifee School District. In 1990, they named the school on Bradley Road in his honor. Rosamond was active in the Antelope Menifee Home Department and the Missionary Society and is the local historian for Menifee Valley. (Courtesy Merle Zeiders.)

**THE KIRKPATRICK FAMILY.** Leonard Kirkpatrick Sr., born in 1893 in Menifee, married Helen Louise and they raised three children: Leonard Jr., Martha Lou, and Lawrence. Leonard Sr. served many years as a trustee for the Menifee and Perris High School boards, and Helen was active in local clubs. Leonard Jr. lives in Woodland, California, Martha Lou was a teacher, and Lawrence taught music in Victorville. Pictured here, from left to right, are (first row) Leonard Sr. and Helen Louise; (second row) Leonard Jr., Lawrence, and Martha Lou. (Courtesy Leonard Kirkpatrick Jr.)

**WALTER AND FRANCES ZEIDERS.** Walter (1886–1974) was born in Pennsylvania. He worked his way across the country, riding his motorcycle, and arrived in California in 1909. Frances (1893–1961), born in Menifee Valley, attended the local schools and spent the rest of her life in the valley. They are pictured here on their wedding day in 1913. Their four children were Dorothy (who died in infancy), Cecil, Leslie, and Merle. (Courtesy Merle Zeiders.)

**GEORGE D. EVANS FAMILY.** George (1897–1981) was born in the valley and Leta (1898–1975) came from Connecticut. They married in 1919 and raised three daughters: Alpha Leta, Darleen, and Elinor. The family lived on Antelope Road and part of the year operated the fish camp at Railroad Canyon Lake, now Canyon Lake. The daughters, with their husbands, also operated the resort in later years. Pictured here, from left to right, are (first row) Leta and George; (second row) Alpha, Elinor, and Darleen. (Courtesy Elinor Martin.)

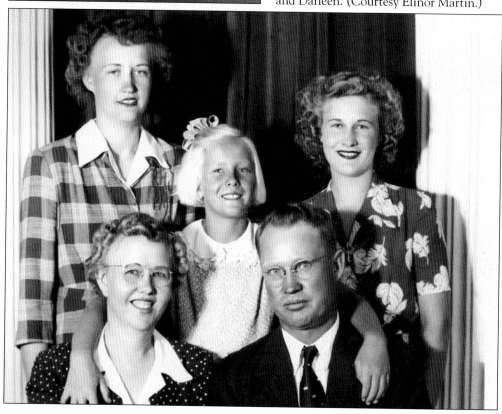

**VIOLET EVANS BEALL.** Violet (1907–1959), the youngest daughter of Henry and Ella Evans, married Hubert Broesamle Sr. and had a son, Hubert Jr. They divorced and she married Albans "Billy" Beall in 1931, the son of pioneer Albert Beall. Violet and Billy resided on Murrieta Road north of Garbani Road and raised four children: Alice, James, Milton, and Susan. This photograph is at her graduation from Perris High School. (Courtesy Elinor Martin.)

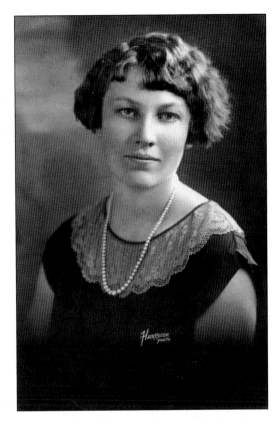

**MARGUERITE EVANS TEEL.** Marguerite (1900–1963) spent her entire life in Menifee Valley. Her parents were Henry and Ella Evans. Harry Schroeder of Perris was her first husband and the father of her children, Dwight and Helen. After her divorce, she married Clay Teel, son of J. B. and Nancy Kirkpatrick Teel. They had a daughter Roberta, pictured here with her parents in front of their house on Murrieta Road. (Courtesy Elinor Martin.)

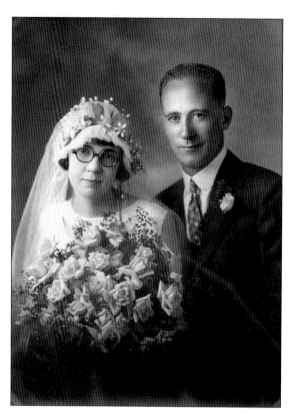

**JOHN HENRY AND MARIE HARRISON.** Marie Twinem was married to John Henry Harrison in Anaheim in 1929. The couple lived on the Kohlmier ranch where John had lived since he was a young boy. John farmed in Menifee and Arvin, near Bakersfield. Marie taught school and was a charter member of the Antelope Menifee Home Department, founded in 1931. She died in a car accident in 1938. (Courtesy John R. Harrison.)

**JOHN RICHARD AND BARBARA HARRISON.** John R. and Barbara Harrison, children of John Henry and Marie Harrison, were born at the Kohlmier/Harrison ranch. John graduated from California Polytechnic State University at San Luis Obispo, and Barbara attended Antelope School before moving to Bakersfield with her aunt Sarah Pouncey. She married Wayne Seacrist, and they had four children. John R. stayed in Menifee. (Courtesy John R. Harrison.)

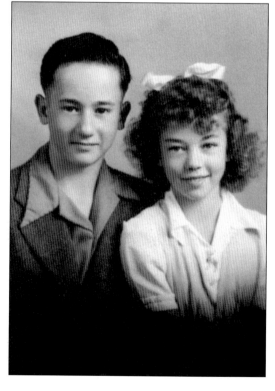

**STANLEY AND BELLE MCGRATH.** Stanley was born in Santa Barbara in 1900 and came to the valley with his parents in 1912. Belle came from Connecticut in 1907. They met and married at Hemet in November 1919. This photograph shows her wearing her mother's wedding dress. She was a wonderful cook, and he was an avid rock hound. Their niece Elinor has fond memories of spending the summers at Oceanside with them. (Courtesy Ann McGrath.)

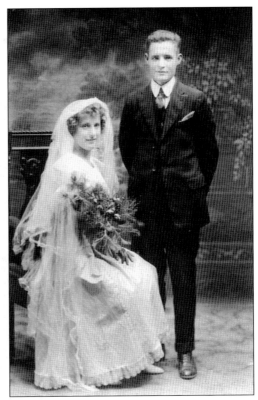

**THE STANLEY MCGRATH FAMILY.** Stanley and Belle had one son, John, also known as "Max" to valley residents. Unfortunately he preceded them in death. Their grandson Jack lives in Menifee with his wife, Ann, and owns J and A McGrath Auto Repair. Their daughter Tracy also resides in the valley. Jack and Ann are the parents of Jeremy McGrath, the 11-time Supercross Champion. (Courtesy Elinor Martin.)

**JOYCE AND CORA WICKERD FAMILY.** Joyce (1889–1976) and Cora Swanson (1898–1964) were married in 1921 in Los Angeles. They raised two children, Robert and Rose. Joyce served in World War I. They came to Menifee and lived in the house his father built in 1907. He grew fruit trees and kept 100 hives of bees. Their son Robert kept the bee business going until he retired to Oregon in 1982. Rose also lives out of the area. (Courtesy Rose Washburn.)

**H. LEE HAUN AT OCEANSIDE.** Lee's parents, Mr. and Mrs. Harry M. Haun, lived in Cottonwood Canyon. Lee married Nina, the daughter of Alden and Zona Walker Drake, on May 1, 1920. Their only child was Wallace, who had two daughters, Connie and Lynn. Lee was Riverside County road foreman for the Menifee District and Haun Road is named for him. Lee's great-granddaughter and family now live in Menifee. (Courtesy Loretta Eckes.)

**MERWIN AND CLARA SHOOK.** Pictured here, from left to right, are Merwin and Clara Shook, Leona Wickerd, and Loretta Shook. Merwin came to the valley in 1932 at the age of 14 and lived with Callie Roberts after her husband died. He married Clara in 1939, and they had three children. He did farm work, served in the air force, and worked as a mechanic in Hemet. He opened his own auto repair shop in later years. (Courtesy Loretta Eckes.)

**THE SHOOK CHILDREN.** The children of Merwin and Clara Shook, from left to right, are Calvin, Loretta, and Lorraine. Calvin married, lives in the valley, and is retired from the Sun City Post Office. Loretta married, moved away, and has returned to the valley. Unfortunately Lorraine passed away. (Courtesy Loretta Eckes.)

OLIVER AND INA WICKERD. Oliver (1895–1960) and Ina (1906–1956) both arrived in Menifee when they were young and spent the rest of their lives there. They married in 1924 and had seven children. Oliver worked for Lee Haun in the road department. The family home was on the northwest corner of Scott and Cox Road. This photograph, taken in 1954, was at the wedding of their daughter, Alice, to Sammy Burton. (Courtesy Alice Burton.)

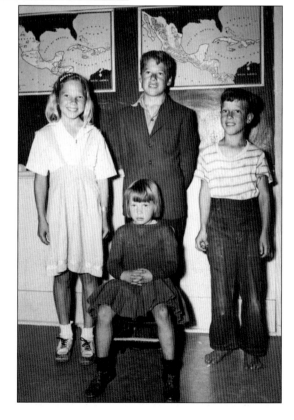

OLIVER WICKERD CHILDREN. This photograph, taken in 1947, shows four of the Wickerd children. Pictured here, from left to right, are Alice, Roger, Phillip, and Evelyn (seated); missing are the two eldest, Mildred and Oliver Jr. The children, all born in Menifee, attended the local schools. Phillip is the only one living in California now. (Courtesy Loretta Eckes.)

THE CORUM FAMILY. Ezra and Muccolla (Spencer) Coram and children Paul, Ruth, and Ralph moved to Menifee in 1920. He traded property in Pasadena for 160 acres on Garbani Road, a half-mile west from the present I-215. Harvey Christian originally built the house. Earlier occupants were the families of Plath and Eisenhart. Ezra was a trustee on the Menifee School Board. They sold their ranch and moved to Riverside in 1963. (Courtesy Alpha Schekel.)

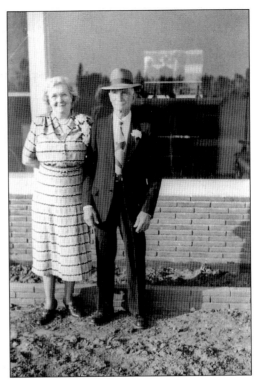

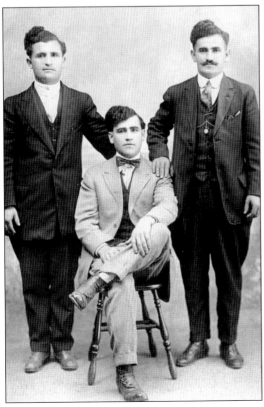

THE BOURIS BROTHERS. George, Ted, and Sam Bouris came to this country from Greece. George originally came alone to Boston in 1904 at age 14 years and worked his way across America on the railroad. He worked in San Francisco after the great earthquake of 1906 clearing rubble. He moved to Los Angeles and sent for his brothers Ted and Sam. In 1922, they bought 640 acres at the southwest corner of Antelope and Keller Roads. (Courtesy Betty Bouris.)

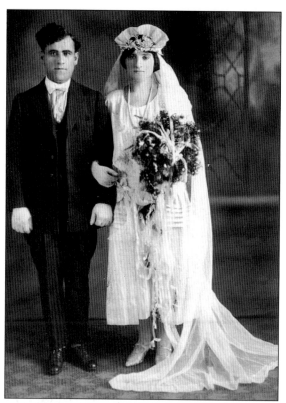

**GEORGE AND MARY BOURIS, 1922.** Mary's brother sent for her to come from Greece and help his wife with their home in Los Angeles. George and Mary were married there in 1922. George owned a three-story billiards hall in Santa Barbara and the couple lived there. However they all wanted to return to the country life they had known in Greece. Hence the three brothers bought the farm in Menifee Valley in 1922. (Courtesy Betty Bouris.)

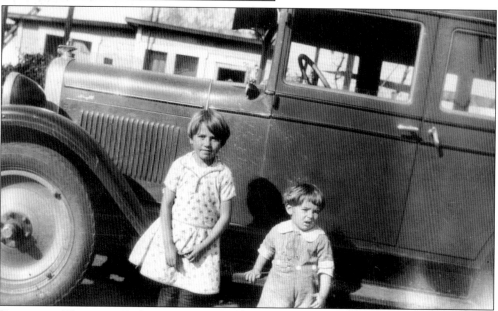

**POULA AND HERCULES BOURIS.** George and Mary Bouris raised their two children on the Bouris brothers ranch on Antelope Road. Poula and Hercules walked to the one-room Antelope School, a mile north of their house. They fondly remember their two special teachers, Mrs. Heers and Mrs. Snow. Poula married and moved to Los Angeles. Hercules married and, like his father before him, continued to farm in Menifee Valley. (Courtesy Betty Bouris.)

**SAM AND MARIA BOURIS.** Sam worked long and hard on the family farm in Menifee Valley. He finally was able to make a trip to Greece in 1954. There he met and married Maria, a niece of his sister-in-law Mary Bouris. Maria came to the United States in 1955 to join her husband on the farm where they lived until it sold in 1961. Then they retired to a home located on Highway 395, south of Scott Road. (Courtesy Peter Bouris.)

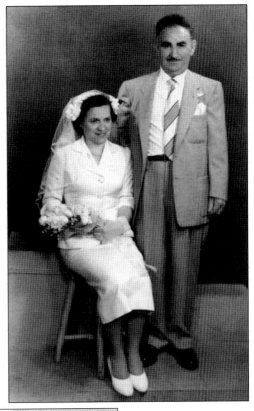

**SAM BOURIS FAMILY.** Sam and Maria Bouris were blessed with a son, Peter, in 1957. Sam retired and spent time with his new family and continued to grow fruit trees and garden at his new house on Highway 395. Sam passed away in 1964, and Maria and Peter continued to live there. Peter became a partner in Bouris ranches in 1982 and continued until he retired in 2005. Peter and his wife, Henny, have two daughters, Lisa and Jenna. (Courtesy Peter Bouris.)

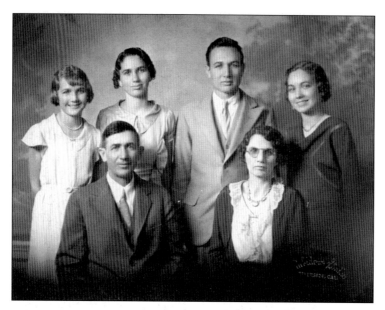

CHARLES BAILEY FAMILY. Charles and Laura Bailey (front row) pose with children, pictured from left to right, Gladys, Ida Mae, Luther, and Leota Bailey. "Charlie" did water witching, was good at doctoring animals, and was always available if you needed him. The couple was the first to welcome newcomers to the community. (Courtesy Sandra La Fon.)

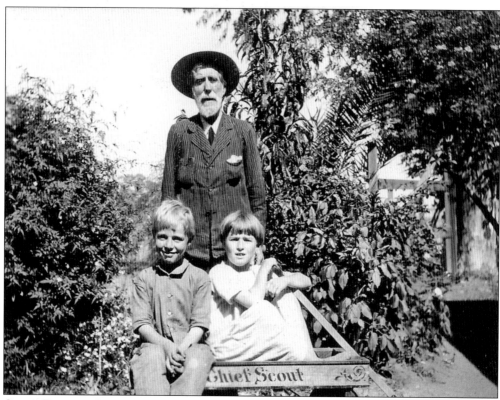

CALLIE ROBERTS CHILDREN. Charles and Callie (Walker) Roberts had two children, Alice (right) and Lerner (left). They are pictured here with their grandfather Oliver Roberts at their home on Briggs Road. Alice married Louis Brown and spent her life in Winchester. Lerner married but never had children. Granddaughter Linda has Callie's trunk with numerous old photographs of the early days in Menifee Valley. (Courtesy Linda Brown.)

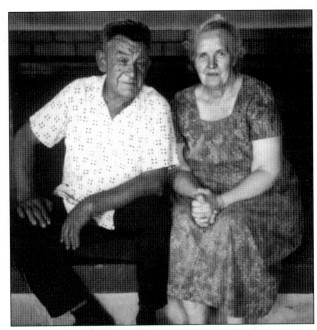

**EDWARD AND CHRISTINE WRIGHT.** The Wright family came to Menifee around 1932 from Los Angeles. They lived a short time in Wildomar, trying to figure out a way to reach their homestead property. The Bouris family graciously gave them access across their property. Edward worked away from home often, and Christine became active in all community affairs. She made beautiful quilts and every young couple received one as a wedding gift. (Courtesy Rhoda Wright.)

**PAUL AND KAREN WRIGHT.** Edward and Christine Wright had two children, Paul and Karen. School was three miles from their house and transportation was a horse or Old Joe, the donkey. Their house was too far from the mail route, so the children would bring the mail home from a box near the school. Both children attended local schools. Paul still lives on Wright property, and Karen lives in Oceanside. (Courtesy Rhoda Wright.)

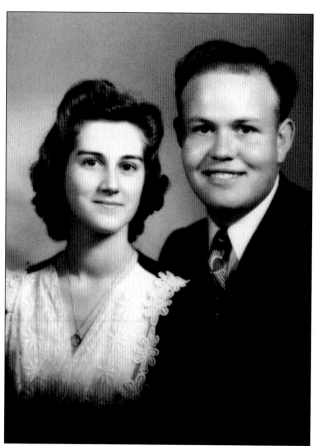

LESLIE AND MAE ZEIDERS. Leslie was born in Menifee and lived there most of his life. As a young man, his hobby was building and flying model airplanes. Mae was a native of Pennsylvania. She began corresponding with him as a pen pal and they later married in 1944. This is their wedding photograph. Four children were born to this union. He served in the air force and farmed with his brother Merle until 1960. (Courtesy William Zeiders.)

LESLIE ZEIDERS'S CHILDREN. Pictured here, from left to right, are Cynthia, Linda, Kenneth, and William (in front). These are the children of Leslie and Mae Zeiders, taken in the early 1960s. The children, born in Menifee, attended the local schools. The boys live in Bakersfield and the girls in Idaho. (Courtesy William Zeiders.)

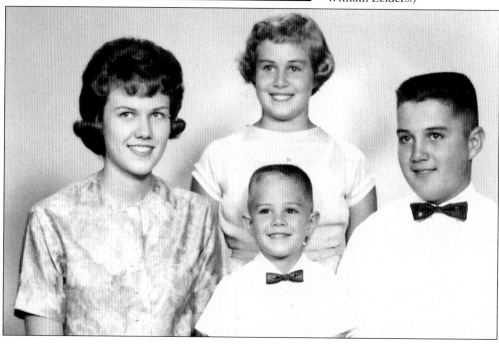

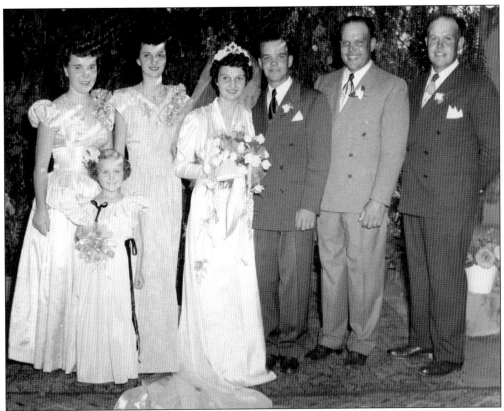

**MERLE AND INA MAY ZEIDERS.** Merle and Ina May were married in 1950 at her uncle Charlie Bailey's home. Pictured, from left to right, are Mary Jean Lennie, Margaret Morrison, Ina May, Merle, and brothers Cecil and Leslie. The flower girl is Cynthia, a niece. The children of this couple are in the photograph below. Merle has been a farmer all of his life and Ina May worked 30 years for the Menifee School District. (Courtesy Merle Zeiders.)

**MERLE ZEIDERS'S FAMILY.** Pictured here, from left to right, are Gary, Sharon, David, and Donald, the baby. The children still reside in Menifee with their families. They have a combined total of 14 children and 13 grandchildren. They are the sixth generation of the Henry and Ella Evans family. (Courtesy Merle Zeiders.)

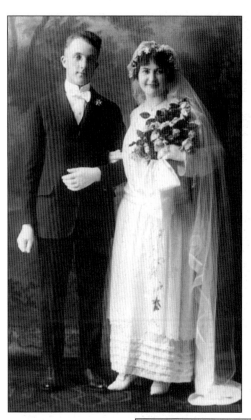

**ERDMAN AND LEONA KRUBSACK.** Erdman and Leona were married in 1919 in Los Angeles. He farmed in Pasadena and Lancaster before they moved to Menifee. Erdman's occupation was always a farmer. They had two children, Louis and Sadie. Erdman and Louis bought a 180-acre farm in 1941, known as the Boardman place. It was located on the northeast corner of Wickerd and Evans Roads. (Courtesy Kathryn Krubsack.)

**ERDMAN AND LEONA KRUBSACK'S 25TH ANNIVERSARY.** Pictured here, from left to right, are Sadie, Erdman, Leona, and Louis celebrating Erdman and Leona's 25th anniversary in 1944 at their son's home. The occasion was special, and the entire community was invited. Sadie married John Rubin and moved to Holtville, California. They had five children of their own: Ronald, Shirley, Tom, Margaret, and Miriam. (Courtesy Kathryn Krubsack.)

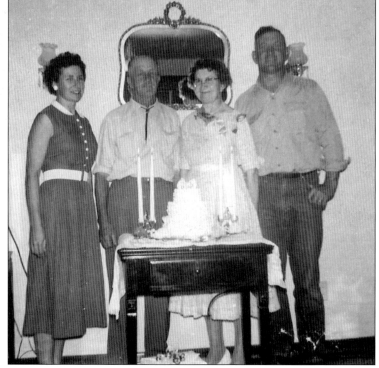

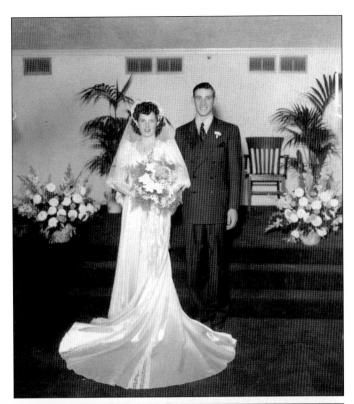

**LOUIS AND KATHRYN KRUBSACK.** Born in Los Angeles, Louis married Kathryn, who was from Trona. They married in 1942 and moved to Menifee in 1945 after Louis served three and half years in the navy. They built a house on Wickerd Road in 1946, and Kathryn still resides in the original home. Louis and his father also built a home on the property for Kathryn's parents, Arthur and O'Neida Vogel. (Courtesy Kathryn Krubsack.)

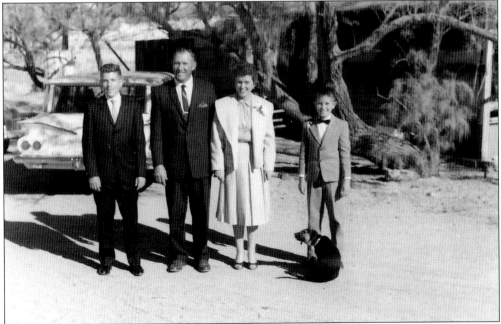

**LOUIS KRUBSACK FAMILY.** Louis and Kathryn Krubsack raised two boys, Robert and Gary, and have three grandchildren. They attended local schools but now live out of the area. Louis served as a school trustee for 30 years for Menifee and Perris High Schools. Kathryn was active in the Antelope Menifee Home Department and other clubs. (Courtesy Kathryn Krubsack.)

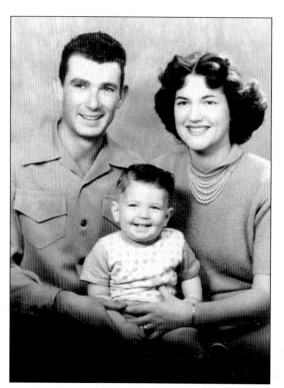

**HERCULES AND BETTY BOURIS.** Hercules and Betty were married in 1950. They bought the old Drake place and began farming. Michael was born in 1951 and his dad painted "Herk Bouris and Son" on the mailbox to announce his birth. Their daughter, Mary Jane, was born later. Hercules passed away in 2004, but Betty, Michael, and his family still live on the ranch. (Courtesy Betty Bouris.)

**MICHAEL AND MARY BOURIS.** Michael and Mary Bouris were the third generation of Bourises to live in Menifee Valley. They attended local schools, and Mary was active in the Loping Lads and Lassie's 4-H Club. Michael attended college at Polytechnic State University at San Luis Obispo. Mary attended San Diego State University and now lives in San Diego. Michael and his wife, Elese, live on the ranch and their grandson Dylan is the fifth generation of the Bouris family to have lived there. (Courtesy Betty Bouris.)

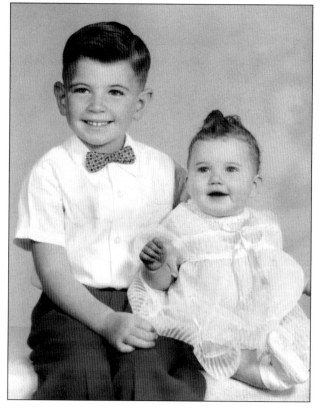

**JOHN RICHARD AND JAN HARRISON.** John R. and Jan Harrison were married in 1955. Their home is on the Harrison ranch where John grew up. They owned and operated Dan's Feed and Seed in Perris. John started the Perris Panthers 4-H Club, is a charter member of the Perris Rotary, and was a Farmer's Fair board member for 37 years. They raised prize racehorses on the ranch. Jan was also active in all the clubs. (Courtesy John R. Harrison.)

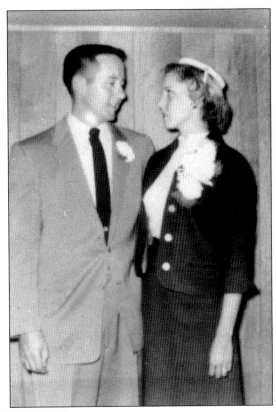

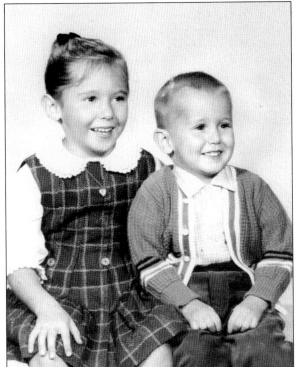

**TAMI AND DICK HARRISON.** Tami and Dick Harrison were born on their parent's ranch. Both graduated from Polytechnic State University at San Luis Obispo, and growing up, they were active in the Perris Panthers 4-H Club and the Loping Lads and Lassies. Tami married and moved to Wyoming and has one daughter. Dick manages Dan's Feed and Seed and lives on the ranch with his wife and three children, who are the fifth generation to live in Menifee Valley. (Courtesy John R. Harrison.)

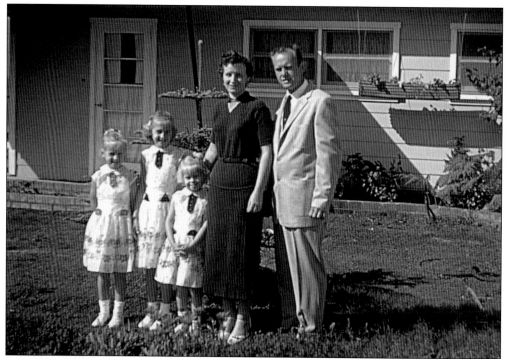

**PAUL WRIGHT FAMILY.** Paul moved to Menifee with his parents, Edward and Christine Wright, when he was four years old. He attended Antelope and Perris High School. After marrying his wife, Betty, in 1948, they moved to San Diego for several years. They returned, built a home on Wright property, and Paul worked with Riverside County Building Department. They have three daughters, Debra, Rhoda, and Brenda. (Courtesy Rhoda Wright.)

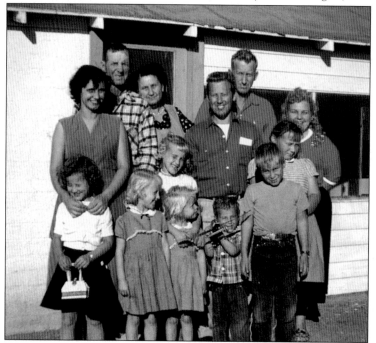

**JOE WOODS FAMILY.** Joe and Bertha Woods came to Menifee around 1945 with their family and worked on the Newport ranch. Pictured here, from left to right, are (first row) Terri Wickerd, Rhoda and Brenda Wright, Michael Wickerd, and Ronnie Woods; (second row) Helen Woods Wickerd, Debra Wright, Rodney Wickerd, Nancy, and Phyllis Woods; and (third row) Joe, Bertha, and Dale Woods. (Courtesy Rhoda Wright.)

**HERBERT AND KATHRYN CHRISTENSEN, 1952.** Herbert Christensen was born in Menifee and his wife, Kathryn, was from Arkansas. She grew up in Hemet, and they were married in 1952. They rented a house on Murrieta Road near Holland because it had telephone service. Later they bought a house further south where they live now. He was a school trustee for many years and an officer in the Rural Center. (Courtesy Herbert Christensen.)

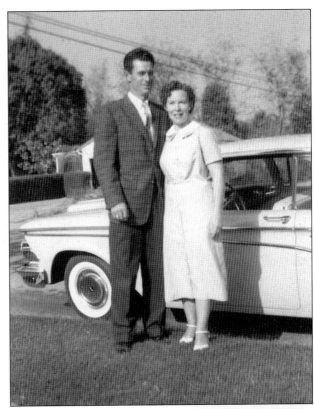

**HERBERT CHRISTENSEN FAMILY.** Herbert and Kathryn have two children, Steven and Martin. The boys, born in the valley, attended all the local schools and now live in homes near their parents. They married and gave their parents three grandchildren. Those children are now the fifth generation of Christensen family to live in the valley. (Courtesy Herbert Christensen.)

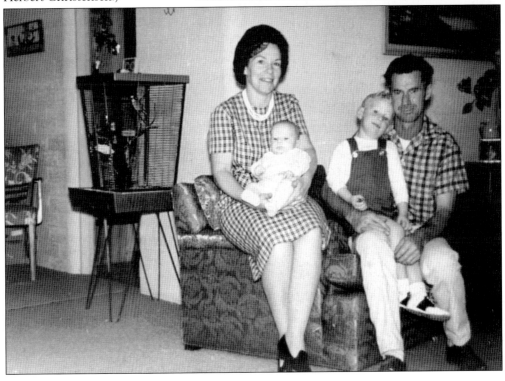

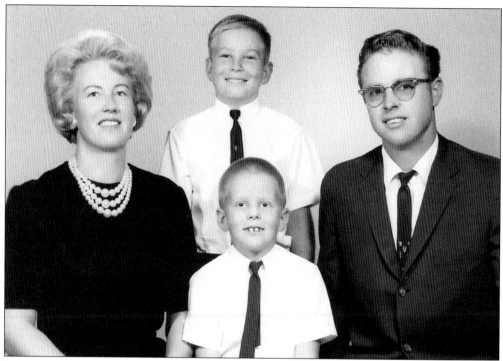

**DONALD AND ELINOR MARTIN FAMILY.** Elinor attended the Antelope one-room school. During high school, she met Donald and married him in 1951. After his service in the army, they moved to Railroad Canyon Lake and operated a resort there. They have two sons, Stephen and Wayne, who live out of the area. She is the third generation of the Evans family and the fourth generation of the Ferrell family to settle in the valley. (Courtesy Elinor Martin.)

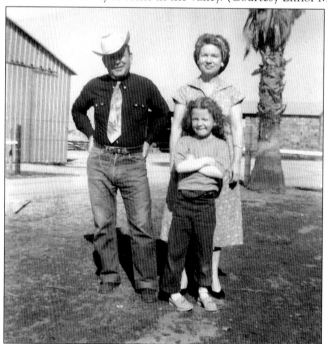

**JOE MORGAN FAMILY.** Joe, Edna, and Texanna Morgan lived on the Audie Murphy ranch. Joe was the manager and took special care of Audie Murphy's horses. Edna prepared large platters of hamburgers for Audie and his crew when they came to visit and worked with the horses. The family moved when Bob Hope bought the ranch. Joe then managed the Clydesdale horse ranch on Briggs Road for many years. (Courtesy Texana Schaden.)

**EMILY MAXWELL MCELWAIN.** Emily was a native of Bellingham, Washington. She met and married Norbert McElwain in Southern California. They raised two children, Clark and Bonny. Emily taught at the Menifee School for 15 years, starting around 1956. She held a bachelor of arts degree from the University of Redlands. She loved her home and garden, spending much time with her plants. (Courtesy Nina McElwain.)

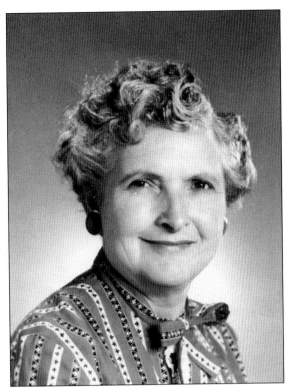

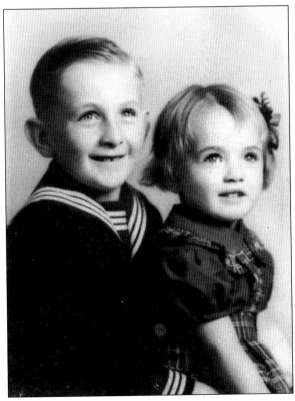

**THE MCELWAIN CHILDREN.** Clark and Bonny McElwain were the only children of Norbert and Emily. They grew up in the Menifee Valley. Bonny was active in the Loping Lads and Lassie's 4-H club. She died in a car accident in 1958 at age 17. Clark married Nina and they stayed in the valley where he operated a hay business. She owned a flower shop in Sun City. They raised four daughters, Bonny, Caroline, Denise and Sharon. (Courtesy Nina McElwain.)

DOROTHY DODGE MCELHINNEY. Dorothy and her husband, Dr. Phillip McElhinney, bought the Baxter ranch in 1931. She herded horses along trails from Wyoming to Menifee to stock the 310-acre Pinto ranch. The family, with children Marcie and Andrew, moved to Menifee in 1941. Dorothy raised, trained, and sold horses. She started the first 4-H horse program in the state and shared her knowledge with members for 40 years. She was also a graduate of the University of Wisconsin. Marcie and Andrew attended local schools. Marcie married James Stimmel and moved to Texas but returned to Menifee. She has children and grandchildren living there today. Andrew married Camille and they raised their children in Menifee and in Wildomar. (Courtesy Andy McElhinney.)

# Six
# CLUBS AND RECREATION

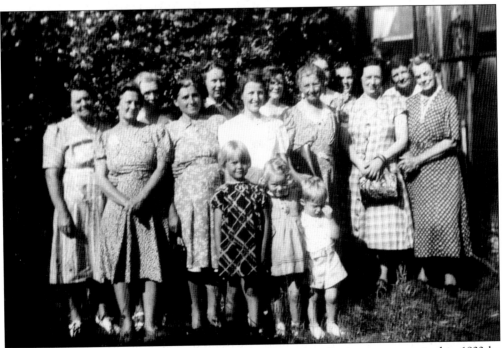

ANTELOPE-MENIFEE MISSIONARY SOCIETY. The Missionary Society was organized in 1933 by Lucy Eldridge, the teacher at Antelope School, as part of the Women's Home Missionary Society of the Methodist Church. Several years later, it was changed to an interdenominational group to attract more members. Their purpose was to spread God's love by helping others and to receive spiritual help in meeting together. There were 30 members on the roll call in 1968. (Courtesy Menifee Valley Historical Association.)

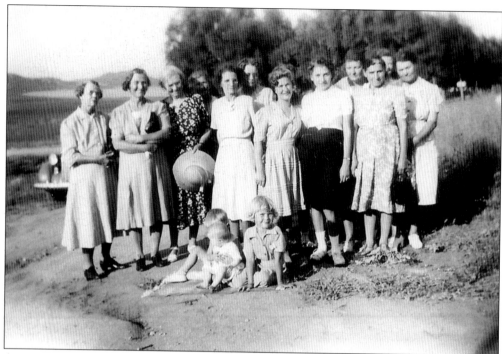

ANTELOPE MENIFEE HOME DEPARTMENT. The Home Department, founded in 1931, has served the community continuously to the present day. Today the group has become the Antelope Menifee Women's Club. This group, among other services, lobbied the Public Utilities Commission and was successful in getting a telephone line into the valley in 1958. The photograph above shows the group in the early 1940s. Pictured here, from left to right, are Norma Brown, Callie Roberts, unidentified, Lizzie Drake, Laura Bailey, Hazel Brown, Darleen Evans, Poula Bouris, Christine Wright, Mary Bouris, unidentified, and Karen Wright (in front), looking at the camera. The photograph below, taken at the Wrightview ranch in 1947, shows some of the same women. Robert is standing in front of his mother, Nan Sanders, and someone in the back row holds his little sister, Rolann. (Courtesy Linda Brown.)

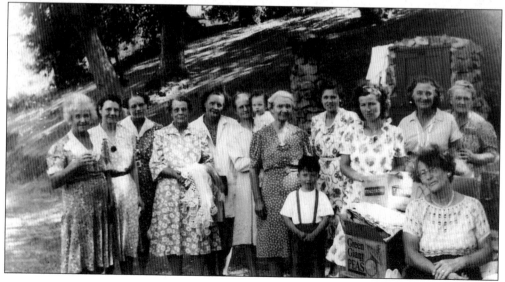

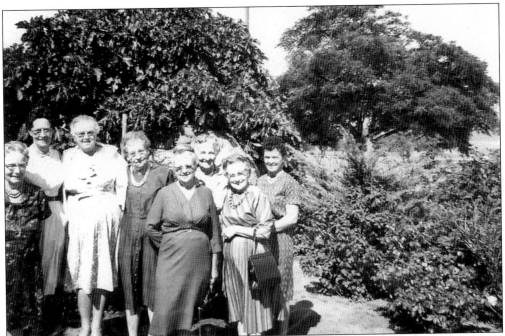

**MENIFEE CANASTA CLUB.** Longtime friends and neighbors in Menifee formed a Canasta Club in the 1950s, as the card game was fashionable at the time. These ladies met in one another's homes, played cards, and exchanged recipes, gardening tips, and other ideas. Pictured here, from left to right, are Charlotte Borsh, Nina Haun, Oneida Vogel, Maude Sharrow, Lulu Slifsgard, Callie Roberts, Lillian Divine, and Kathryn Krubsack. (Courtesy Kathryn Krubsack.)

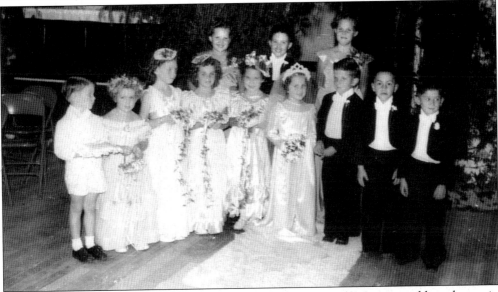

**TOM THUMB WEDDING.** A "Tom Thumb wedding" was enacted at a post-wedding shower in honor of Merle and Ina May Zeiders. The event, at the Rural Center in 1950, had 135 guests in attendance. Pictured here, from left to right, are Victor Renner, Trina Chandler, Dawn Renner, Bonny McElwain, Claudia Zeiders, Rolann Sanders, Robert Sanders, Cindy Zeiders, Arlene Zeiders, Robert Krubsack, Buddy Spencer, and Milton Mehas. (Courtesy Kathryn Krubsack.)

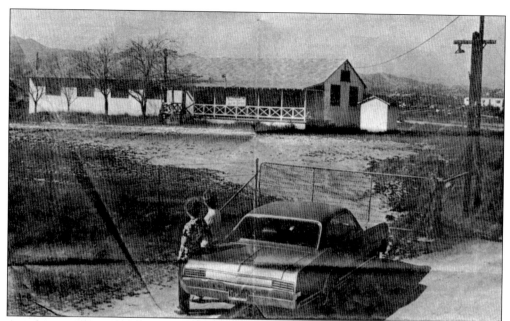

ANTELOPE MENIFEE RURAL CENTER. The newly formed Antelope Menifee Rural Center moved a building from Camp Haun to Menifee in 1947. After remodeling, the large meeting room could seat 100 people. It served the valley as a center for all activities until 1973 when it was purchased by the state to make room for Highway 395. Chester Morrison donated an acre of land at Haun and Garbani Roads for a new building. (Courtesy Press Enterprise.)

RURAL RHYTHM BOYS. This informal band, composed of local residents, played music for the dances at the Rural Center. Entire families attended and the little children learned by dancing with their parents or each other. Pictured here, from left to right, are Norman and Rita Middleton, Peter Reiger, Harry Woods, and Oliver Wickerd. (Courtesy Loretta Eckes.)

**RURAL CENTER OFFICERS, 1950.** Pictured here, from left to right, are Hans Christensen, Hercules Bouris, Chester Morrison, Norman Smith, and Rosamond Morrison. The Antelope Menifee Rural Center Board is the official group that keeps the center functioning. The building is available for rent to churches, community parties, 4-H groups, and is home to the Antelope Menifee Women's Club. (Courtesy Betty Bouris.)

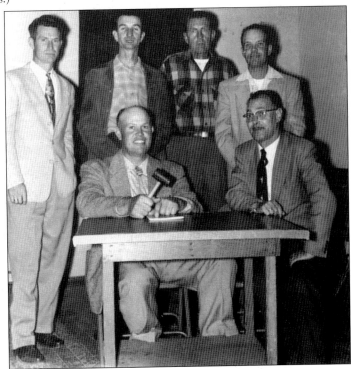

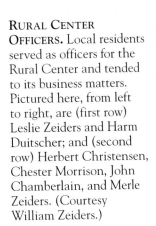

**RURAL CENTER OFFICERS.** Local residents served as officers for the Rural Center and tended to its business matters. Pictured here, from left to right, are (first row) Leslie Zeiders and Harm Duitscher; and (second row) Herbert Christensen, Chester Morrison, John Chamberlain, and Merle Zeiders. (Courtesy William Zeiders.)

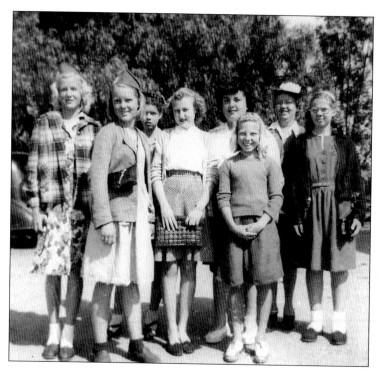

**ANTELOPE 4-H CLUB.** Leta Evans organized a 4-H Club again for the girls around 1945. Learning to sew was the main topic covered, and they attended all the events connected with 4-H, including a stay at Camp Radford in the San Bernardino Mountains. Pictured here, from left to right, are Elinor Evans, Karen Wright, Nancy McGrath, Louise Divine, Mary Rose Lenta, Alice Wickerd, Leta Evans, and Rose Wickerd. (Courtesy Elinor Martin.)

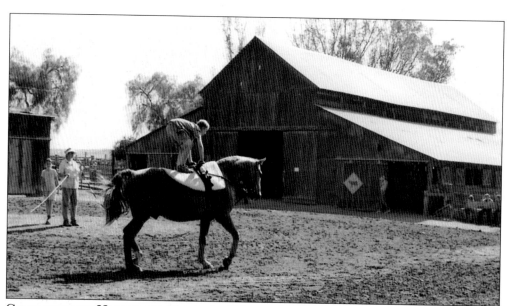

**GYMNASTICS ON HORSEBACK.** This is the 100-year-old barn at the Pinto ranch as Loping Lads and Lassies 4-H members are practicing vaulting. Dorothy McElhinney helped introduce vaulting into the United States, setting up rules of competition. Each summer, she held a horse camp for young people. She was also a charter member of the Palomino Horse Breeders Association and a member of the California Thoroughbred Breeders Association. (Courtesy Marcie Stimmel.)

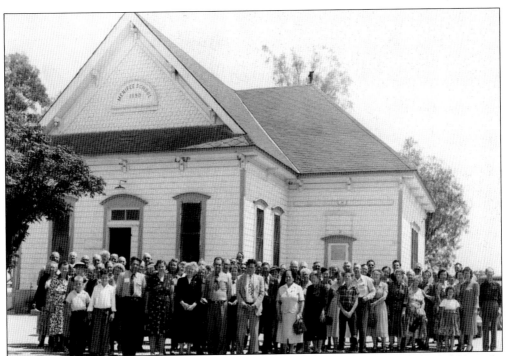

**MENIFEE HOMECOMING REUNION.** Homecoming reunions held at the old Menifee School brought old-timers from all over. Anyone who was a resident or former resident of Menifee Valley was invited. Many had previously attended the same school when they were younger. In 1940, the celebration was the 50th anniversary of the school. Reunions continued and this 1954 photograph was of the last one held there. (Courtesy Menifee Valley Historical Association.)

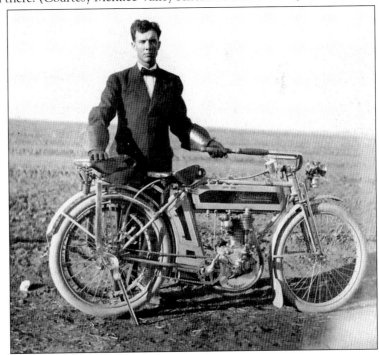

**WALTER ZEIDERS'S MOTORCYCLE.** Walter Zeiders rode this motorcycle from Pennsylvania to California in 1909. He would stop and work at various jobs, and then ride a little further until he ran out of money and would find another job. He arrived in San Bernardino with $17 and a pack on his back. While working on the Reynolds ranch in Menifee, he met Frances Evans and married her in 1913. (Courtesy Merle Zeiders.)

TORREY PINES CAMPSITE, 1912. Another favorite camping area was Torrey Pines, where people pitched tents on the bluff overlooking the ocean. The women are organizing the campsite while the men are tending to the horses that pulled their buggy. The coastal breeze was a welcome change from the heat of Menifee Valley. (Courtesy Rosamond Morrison.)

TORREY PINES BEACH, 1916. Families met at the beach, parked their cars, and enjoyed the day where the children had easy access to the water. At the end of the day, everyone returned to his or her campsites to spend the night. (Courtesy Rosamond Morrison.)

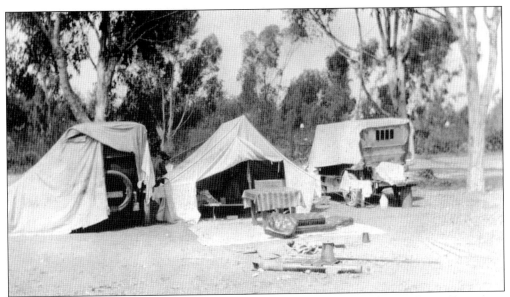

CAMPING AT SAN DIEGO EXPOSITION. The Brown family camped at the San Diego Exposition in August 1916. They were given permission to set up camp on the grounds and later discovered their campsite being described to visitors as a typical farm family. They were amused to be part of the exhibition. (Courtesy Rosamond Morrison.)

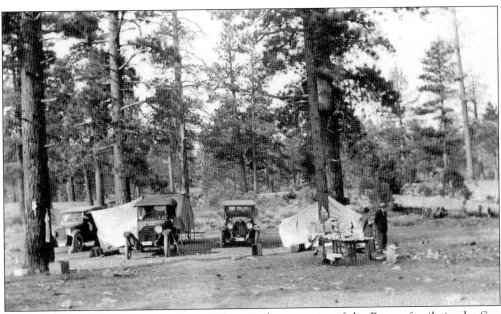

BIG BEAR, CALIFORNIA, 1918. Pictured here is the campsite of the Brown family in the San Bernardino Mountains in September 1918. The mountains offered another retreat during the summer months. Today the trip takes little more than an hour, but it was much longer in those days. (Courtesy Rosamond Morrison.)

LEE LAKE IN ALBERHILL, 1912. Families fished in the San Jacinto River or Lee Lake before the construction of Railroad Canyon Dam. A small dam blocked the Temescal Canyon and runoff water formed Lee Lake. This photograph has the title of "Fishing at Lee's Lake," and shows the Brown family. Now it bears the name of Corona Lake and is open to the public for fishing. (Courtesy Rosamond Morrison.)

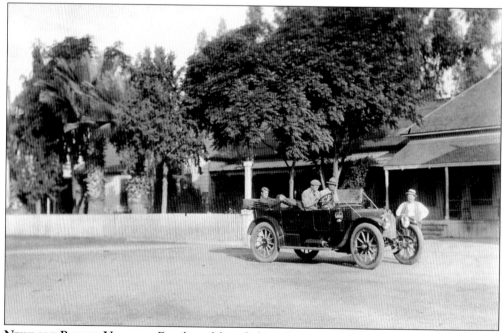

NEWPORT RANCH VISITORS. Family and friends from the city enjoyed motoring to the Newport ranch for a country outing. The large ranch impressed visitors and they in return could enjoy an outing in their new automobiles. (Newport family album.)

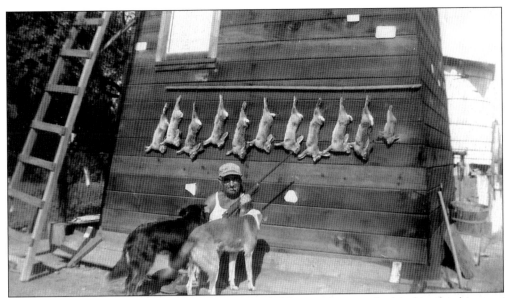

SAM BOURIS'S HUNTING RESULTS. Sam Bouris led hunting parties for his friends who came from Los Angeles and Newport Beach to hunt rabbits, doves, and quail. He always had a gun at hand for protection from rattlesnakes as they walked the hills. The dogs were good hunters too, catching many varmints that plagued crops. (Courtesy Peter Bouris.)

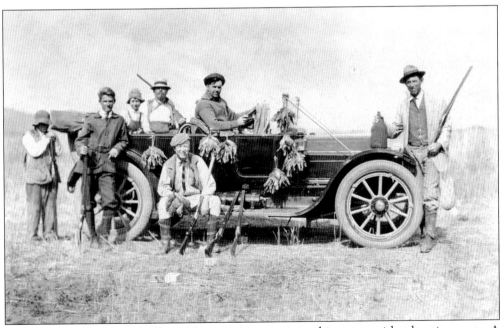

HUNTING PARTY, 1913. William Newport is entertaining his guests with a hunting party. A common practice among ranchers was hunting and eating quail for breakfast when entertaining guests. Wearing a white shirt, William is in the back seat. (Newport family album.)

**HARRISON RANCH VISITORS.** John H. Harrison, in the driver's seat, is posing for the camera with two unidentified men. Benjamin Kohlmier is seated on the running board of the Ford. The barn in the background is still being used and in good condition. (Courtesy John R. Harrison.)

**HENRY EVANS'S NEW FORD.** Henry Evans is sitting in the passenger seat, while his brother, Newton, is in the right rear seat. Charles Young is driving and the other passenger is A. T. Osbrink. Photographed in Elsinore, the group is showing off Henry's new Ford. (Courtesy Elinor Martin.)

# Seven
# SCHOOLS

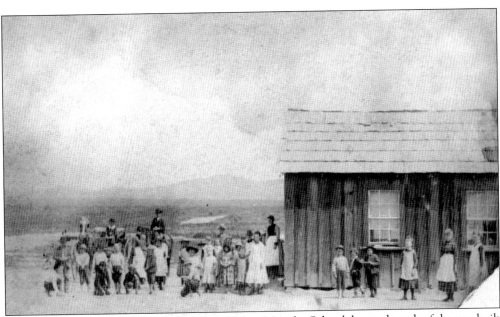

**FIRST MENIFEE SCHOOL, BEFORE 1890.** The first Menifee School, located south of the one built in 1890 on Bradley Road, is pictured here with its students. The teacher was Eliza F. Auld. The photograph is not dated, but the age of certain students place it before 1890. Pictured here are Herman Plath, Roy Ferrell, Rob Hiembach, Jamie Ferrell, Fred Fortine, Charles Cresmer, Wert Kirkpatrick, Paul Schain, Ben Teel, Ivy Martin, Cliff Anderson, Jessie McLean, Trudie Hiembach, Bessie and May Anderson, Millie Godfrey, Alma Teel, Pearl Fortine, Midie Hiembach, Etta Cook, Lela Teel, Bettie Kirkpatrick, Amanda Cresmer, Clara Plath, Elsie Godfrey, R. Walters, Daisy Bonner, Minnie Godfrey, Nola Walters, Nelson Arnold, Roy Cook, and Henry Aiken. (Courtesy Linda Brown.)

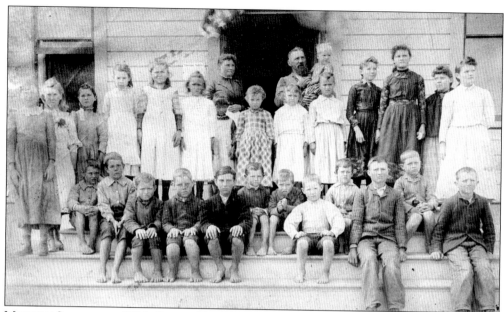

MENIFEE SCHOOL, C. 1891. Pictured here, from left to right, are (first row) Charlie Cresmer, Nelson Arnold, Cliff Anderson, Henry Aiken, Fred Fortine, Rufus Holland, Harvey Teel, Roy Cook, Charlie Pope, Claude Walker, Ben Teel, and John Walker; and (second row) Gertrude Pope, Nola Walters, Lena Holland, Amanda Cresmer, Bessie Anderson, Ruie Walters, Alma Teel, Mary Anderson, Pearl Cook, Zona Walker, Etta Cook, Lita Cook, Nettie Allen, and Margery Allen. The teacher is Miss Auld.

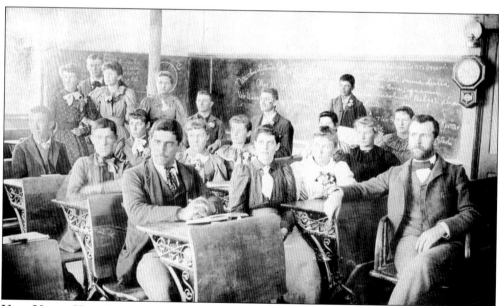

VALE UNION HIGH SCHOOL, 1894–1995. School opened on November 23, 1891, according to the diary of George Davenport, clerk of the board. Only two students came the first day. School stationery in 1896 shows the districts included in the school are Menifee, Antelope, Benedict, Paloma, Winchester, and Rawson. Teachers in the districts are Wilkinson, Marsh, Wickersheim, Palmer, Baker, Guthrie, and McEuen. (Courtesy Linda Brown.)

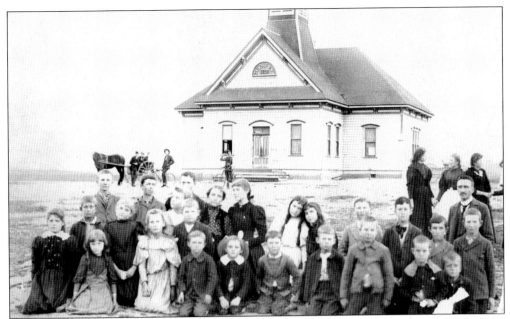

**MENIFEE SCHOOL, 1896.** The date of this photograph is taken from a newspaper article about Leonard Kirkpatrick Sr., dated March 18, 1956. It states, "If today's Menifee Union School District enrollment were divided between it's former two parts—Menifee and Antelope—Menifee's student body would be the same size as it was when this picture of it was snapped 60 years ago." (Courtesy Leonard Kirkpatrick Jr.)

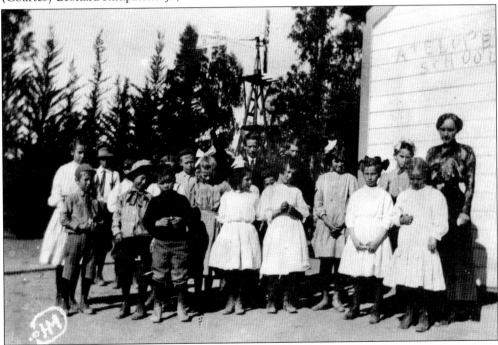

**THE ANTELOPE SCHOOL, C. 1913.** This photograph, taken at the back of the Antelope School, shows the students and teacher Mrs. O'Neil Edmonson. Hazel Brown is one of the students. The school was located on the southeast corner of Scott and Antelope Roads. (Courtesy Rosamond Morrison.)

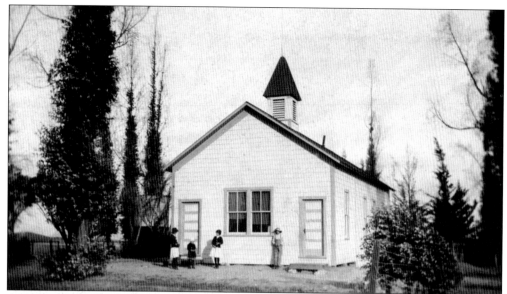

ANTELOPE SCHOOL, NOVEMBER 1913. This photograph shows the front of the Antelope School in November 1913. There was a separate entrance for the boys and girls to put their coats and lunch boxes. The July 30, 1930, board of trustee minutes reveal "the girls hall partition is to be torn out and a high archway installed; the old platform removed and put in a new floor throughout. Mr. Burgess estimates his labor at $125.00." (Courtesy Rosamond Morrison.)

END OF SCHOOL DAY, 1914. Carrying their tin lunch buckets and walking home from school are, from left to right, Walter, Margaret, and Hazel Brown. They attended the Antelope School one mile south of their home. The path went through the wheat field, and the crop was tall that year. Their mother, Norma Brown, grabbed her Brownie 2A camera and snapped this photograph according to Rosamond Morrison. (Courtesy Rosamond Morrison.)

**ANTELOPE SCHOOL STUDENTS, 1914.** This photograph, taken in 1914, seems to be lacking boys. Maybe they were just camera shy, as evidenced below. (Courtesy Rosamond Morrison.)

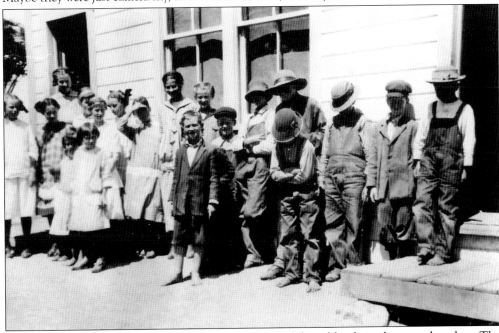

**ANTELOPE SCHOOL STUDENTS, 1915.** Boys evidently did not like their photographs taken. The Brown family album contains numerous photographs of the Antelope School and its early students and teachers. (Courtesy of Rosamond Morrison.)

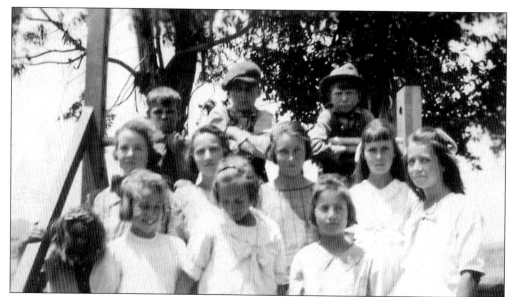

ANTELOPE SCHOOL STUDENTS, 1920. The one-room school housed grades one through eight. The students pictured here, from left to right, are (first row) Erma Wickerd, Winnie Wickerd, Ina Wickerd, Sarah Drake, and Clara Wickerd; (second row) Marian Harp, Deone Drake, Violet Evans, and Rosamond Brown; (third row) Howard Evans, Florentz Evans, and Clarence Simmons. (Courtesy Loretta Eckes.)

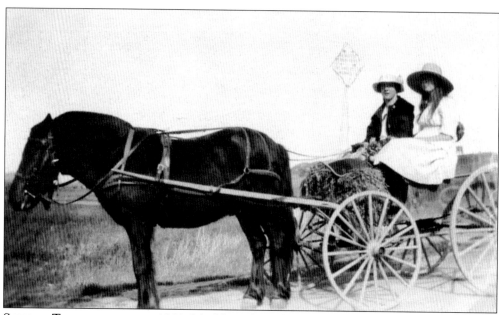

SCHOOL TRANSPORTATION, 1921. Mr. Harp, from the Liberty ranch on Briggs Road, drove his daughter Marian to the Antelope School. Often he stopped at the Brown home and gave Rosamond a ride to school. He was in charge of the livestock at the ranch. Jimmy the horse is pulling the rickshaw. (Courtesy Rosamond Morrison.)

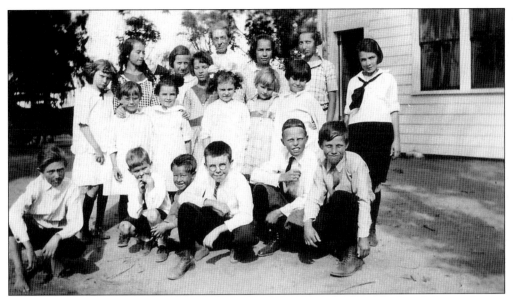

ANTELOPE SCHOOL STUDENTS, 1922. The children in this photograph, from left to right, are (first row) Clarence Simmons, Glen Kirkpatrick, Austin Wickerd, Paul Coram, John Mitchell, and Howard Evans; (second row) Esther Mitchell, Leota Bailey, June Boardman, Ruth Coram, Viola Blackmore, and Edna Evans; (third row) Evelyn Milsape, Clara Wickerd, Sarah Drake, Erma Wickerd, Winnie Wickerd, Iva Drake, and teacher Mrs. Obenchain. (Courtesy Loretta Eckes.)

OLD PALOMA SCHOOL BUILDING. This Paloma School building was located on the southeast corner of Scott and Antelope Roads. When the new Antelope School was built, it was moved next door to the Harrison ranch where it became a bunkhouse. This current photograph shows it is still in good condition. (Courtesy Elinor Martin.)

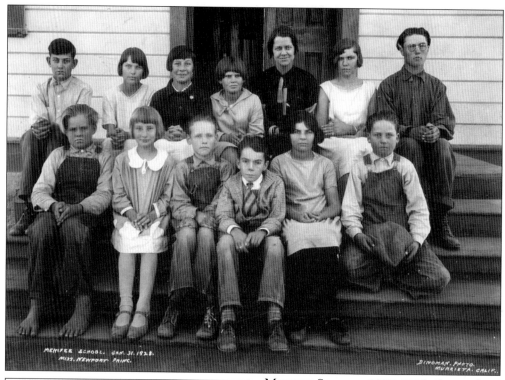

**MENIFEE SCHOOL, 1927–1928.** Some of the students pictured are Harold Pearson, Lorena Pearson, Katherine Pringle, Edna Evans, Robert Evans, Elizabeth Pringle, and Ruby Pearson. Kathryn Newport was the principal. (Newport family album.)

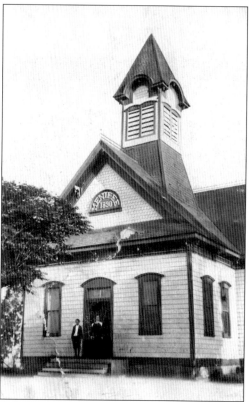

**THE MENIFEE SCHOOL.** This Menifee School, built in 1890, shows off the steeple before its removal in later years. The two-room school closed in 1952 when Antelope and Menifee Schools unified and the new Menifee School was built on Garbani Road, off Murrieta Road. It burned to the ground on July 16, 1971, after standing for 81 years. (Courtesy Alpha Schekel.)

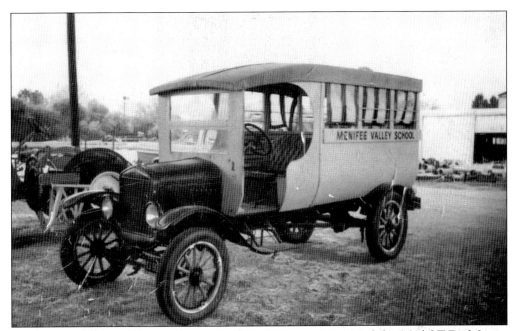

SCHOOL BUS OF 1921–1922. Leon Motte, the current owner, restored this Model T Ford. It was the first school bus to transport the Antelope and Menifee Valley students to Perris Union High School. The students sat on board benches on each side. Ralph Wickerd was the first driver and Jay Wickerd was second. (Courtesy Leon Motte.)

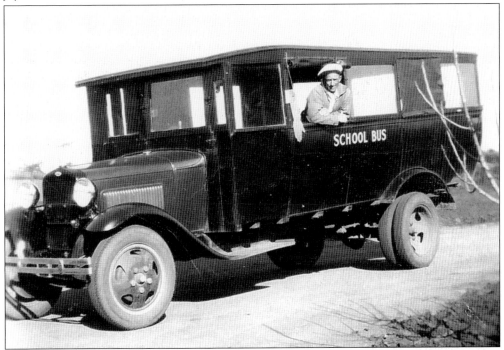

JAY WICKERD, BUS DRIVER. Jay Wickerd drove the school buses to Perris Union High School for 17 years. He is pictured here in the window. Notice the signal arm for the driver. (Courtesy James Wickerd.)

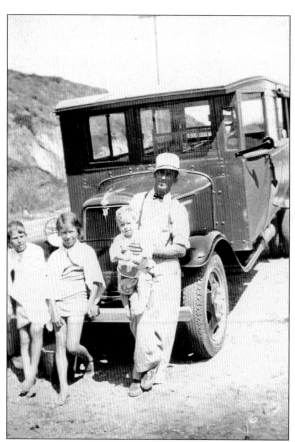

ANOTHER HIGH SCHOOL BUS. Jay Wickerd is pictured here with some children. He had two sons, James and Gale. The bus is a 1935 Ford V8 according to a resident whose brother rode in it. Yellow was the color of the later buses. (Courtesy James Wickerd.)

ANTELOPE SCHOOL STUDENTS, 1931–1932. Pictured here, from left to right, are (first row) Karl Wickerd, Poula Bouris, and Gary Small; (second row) Walter Wickerd, Ruth Wickerd, Dale Small, Ray Coffman, Christine Christensen, Dee Brown, and Herbert Christensen; (third row) Jack Wickerd, Gladys Bailey, Lerner Roberts, Ida Mae Bailey, Grace Crawford, Alpha Evans, Leslie Zeiders, Wallace Haun, and Harold Brown. (Courtesy Alpha Schekel.)

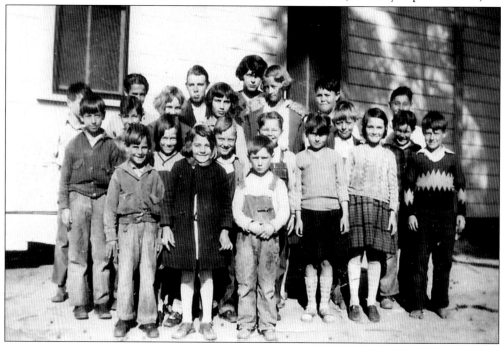

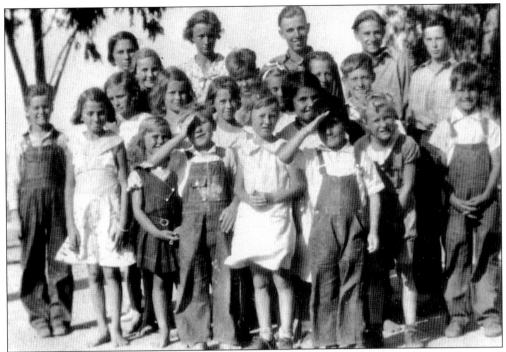

ANTELOPE SCHOOL STUDENTS, 1933–1934. Pictured here, from left to right, are (first row) Ray Coffman, Poula Bouris, Mildred Wickerd, Hubert Broesamle, Vonnie Wickerd, Bernard Lenta, Darleen Evans, and Karl Wickerd; (second row) Dee Brown, Christine Christensen, Ruth Wickerd, unidentified, Mary Rose Lenta, and Herbert Christensen; (third row) Gladys Bailey, Max McGrath, and unidentified; (fourth row) Ida Mae Bailey, Alpha Evans, Lerner Roberts, Merwin Shook, and Garth Warner. (Courtesy Alpha Schekel.)

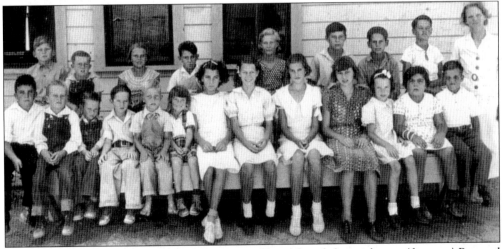

ANTELOPE SCHOOL STUDENTS, C. 1936. Pictured here, from left to right, are (first row) Bernard Lenta, Paul Wright, Ramon Shook, John R. Harrison, Oliver Wickerd Jr., Dorothy Hammond, Poula Bouris, Ruth Wickerd, Betty Cox, Christine Christensen, Judith Warner, Mary Rose Lenta, and Merle Zeiders; (second row) Hubert Broesamle, Clinton Brown, Mildred Wickerd, Hercules Bouris, Darleen Evans, Herbert Christensen, Karl Wickerd, Ray Coffman, and Julia Heers (teacher).

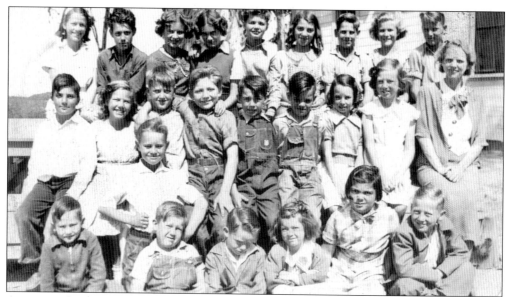

ANTELOPE SCHOOL CLASS, C. 1937. Pictured, from left to right, are (first row) John R. Harrison, Clinton Brown, Ramon Shook, Dorothy Hammond, Mary Rose Lenta, and Rodney Wickerd; (second row) Paul Wright; (third row) Bernard Lenta, Mildred Wickerd, ? Russell, Hubert Broesamle, Hercules Bouris, Merle Zeiders, Judith Warner, Vonnie Wickerd, and Julia Heers (teacher); (fourth row) Ruth Wickerd, Herbert Christensen, Christine Christensen, Betty Cox, Ray Coffman, Poula Bouris, Karl Wickerd, Darleen Evans, and ? Russell.

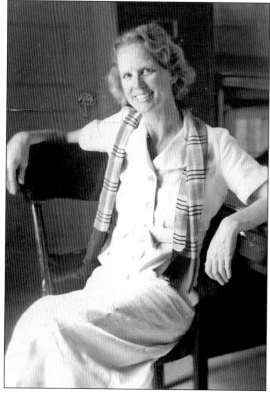

JULIA HEERS, ANTELOPE TEACHER. Julia Heers taught at the Antelope School from 1934 to 1938. She boarded at the Walter Zeiders home since she lived in Corona, and the distance was too far for daily driving. Her salary was $1,250 a school year. The class of 1938 wrote a poem about her. In 1973, she wrote a letter that said is was one of her most precious gifts. (Courtesy Menifee Valley Historical Association.)

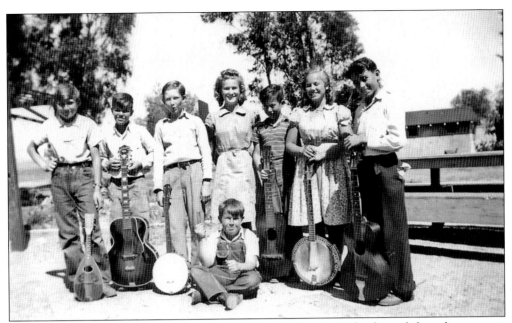

MUSIC STUDENTS, 1940. Mr. Adkins came to the school every Friday for a while and gave music lessons to the upper-grade students. The WPA sponsored the program. Pictured here, from left to right, are Hubert Broesamle Jr., Merle Zeiders, Clark Harris, Darleen Evans, John R. Harrison, Mildred Wickerd, Hercules Bouris, and Clinton Brown. (Courtesy Milton Beall.)

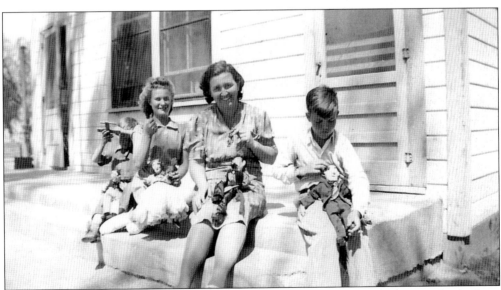

PUPPET ART PROJECT, 1940. Leona Snow taught for five years at the Antelope School. She is pictured here sitting between Darleen Evans (left) and Merle Zeiders. Christine Wright sewed the costumes for the puppets. Leona boarded with the Zeiders family, as did other teachers. (Courtesy Milton Beall.)

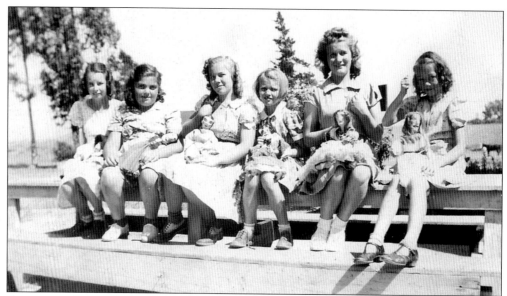

PUPPETS ON DISPLAY, 1940. The girls of the school are displaying their puppets with their pretty costumes, which were made by Christine Wright. Pictured here, from left to right, are Judith Warner, May Rose Lenta, Mildred Wickerd, Alice Beall, Darleen Evans, and Barbara Harrison. (Courtesy Milton Beall.)

ANTELOPE SCHOOL STUDENTS, 1944. Pictured here, from left to right, are (first row) Phillip Wickerd, Alice Wickerd, Lyle Christensen, Gale Wickerd, George Magno, James Beall, and Karen Wright; (second row) Roger Wickerd, James Wickerd, John Drake, and Elinor Evans; (third row) Marcie McElhinney, Virginia Thompson, Oliver Wickerd Jr., John Harrison, Mary Rose Lenta, Clinton Brown, Barbara Harrison, Rodney Wickerd, and Dee Richardson. (Courtesy Lyle Christensen.)

ANTELOPE SCHOOL STUDENTS, 1947. Pictured here, from left to right, are (first row) James Wickerd, Ted Mehas, unidentified, Phillip Wickerd, Gale Wickerd, George Magno, and Lyle Christensen; (second row) Jerry Divine, Evelyn Wickerd, Alice Wickerd, and Claudia and Arlene Zeiders; and (third row) Roger Wickerd, unidentified, Ronald Kay, Elinor Evans, Nancy McGrath, Rose Wickerd, Karen Wright, and teacher Vivian Richardson. (Courtesy Elinor Martin.)

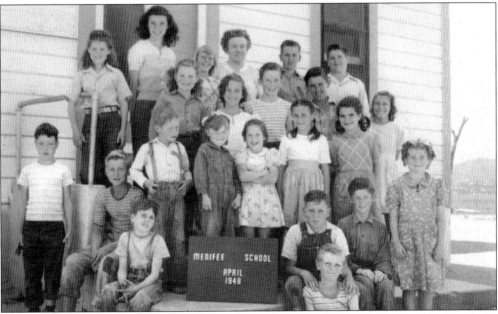

MENIFEE SCHOOL STUDENTS 1948. Pictured here, from left to right, are (first row) Milton Beall, Frank Schultz, Don ?, Frank O'Rafferty, and Suzanne Kurson; (second row) Robert Haines, Bill Woods, Darrel Woods, Elizabeth O'Rafferty, unidentified, Jodene Spencer, Jayette Rostas, and unidentified; (third row) unidentified, unidentified, unidentified, and Roger ?; (fourth row) Annabelle O'Rafferty, Kathleen Conley, Molly Schultz, Mrs. Bennett, James Beall, and John Drake. (Courtesy Milton Beall.)

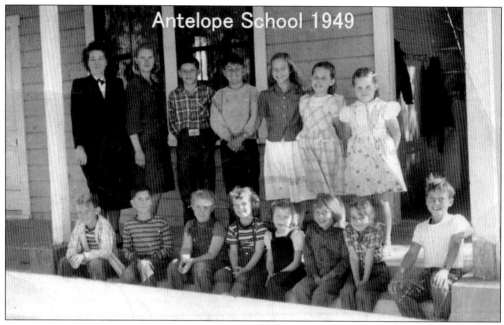

**ANTELOPE SCHOOL STUDENTS, 1949.** Pictured here, from left to right, are (first row) Clark McElwain, Theodore Mehas, Linda Klein, unidentified, unidentified, Evelyn Wickerd, Bonnie McElwain, and Phillip Wickerd; (second row) teacher Mrs. Balding, Karen Wright, Lyle Christensen, George Magno, Alice Wickerd, and Arlene and Claudia Zeiders. (Courtesy Menifee Valley Historical Association.)

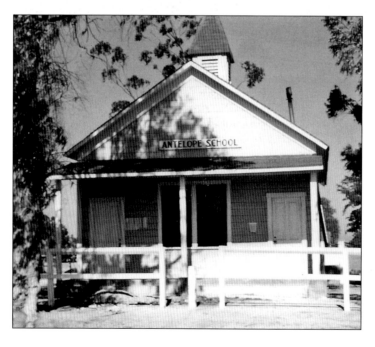

**ANTELOPE SCHOOL HOUSE, 1949.** This photograph shows the school as it looked before the unification with Menifee School in 1952. The State of California bought the property and the building was sold to a rancher. It was moved to another location and was destroyed through neglect. Its former location at the southeast corner of Scott and Antelope Roads is now a small shopping center. (Courtesy Elinor Martin.)

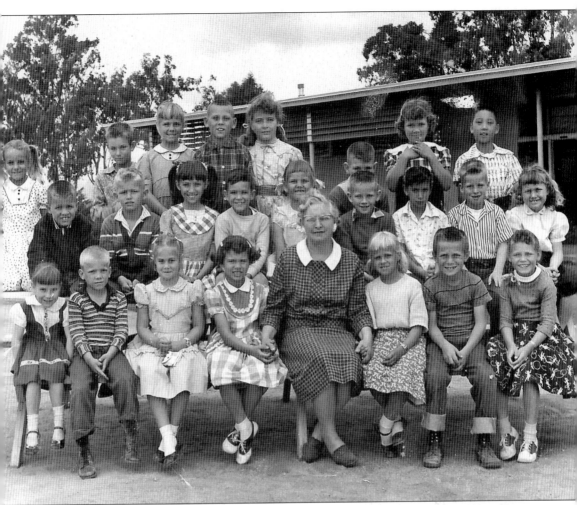

**MENIFEE SCHOOL CLASSES, 1957.** These are the first, second, and third grades. Pictured here, from left to right, are (first row) unidentified, Curt Tate, Linda Zeiders, unidentified, Emily McElwain, Brenda Tate, Robert Avakian, and unidentified; (second row) Gary Zeiders, unidentified, Nancy Hallberg, Phillip Hallberg, Charlotte Lowrey, unidentified, unidentified, unidentified, and Diana Mills; (third row) Carolyn Von Moos, unidentified, unidentified, unidentified, Bonnie Waddell, Mike Bouris, Marsha Robbins, and Mark Jang. (Courtesy Merle Zeiders.)

## Across America, People are Discovering Something Wonderful. Their Heritage.

Arcadia Publishing is the leading local history publisher in the United States. With more than 3,000 titles in print and hundreds of new titles released every year, Arcadia has extensive specialized experience chronicling the history of communities and celebrating America's hidden stories, bringing to life the people, places, and events from the past. To discover the history of other communities across the nation, please visit:

### www.arcadiapublishing.com

Customized search tools allow you to find regional history books about the town where you grew up, the cities where your friends and family live, the town where your parents met, or even that retirement spot you've been dreaming about.